BANKSY

BANKSY
A GRAPHIC NOVEL

Text by FRANCESCO MATTEUZZI

Illustrations by MARCO MARAGGI

Edited by BALTHAZAR PAGANI

PRESTEL

MUNICH · LONDON · NEW YORK

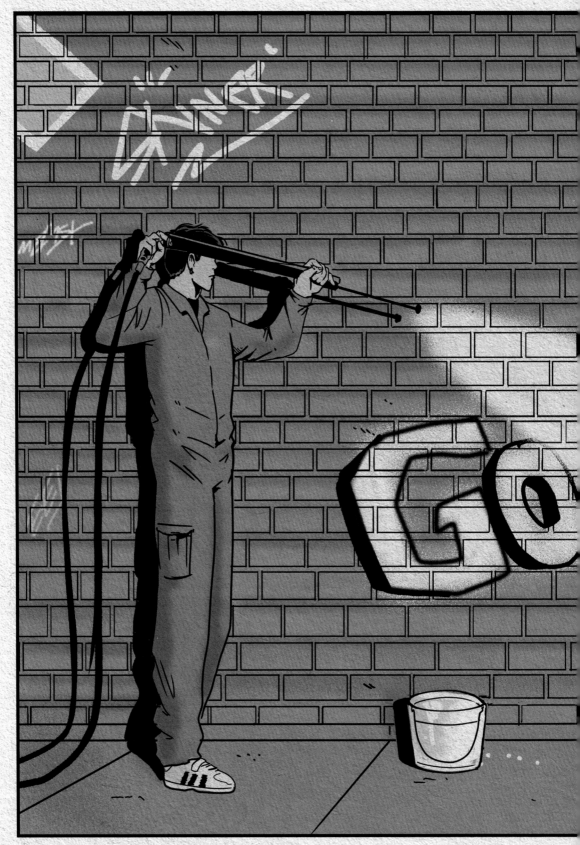

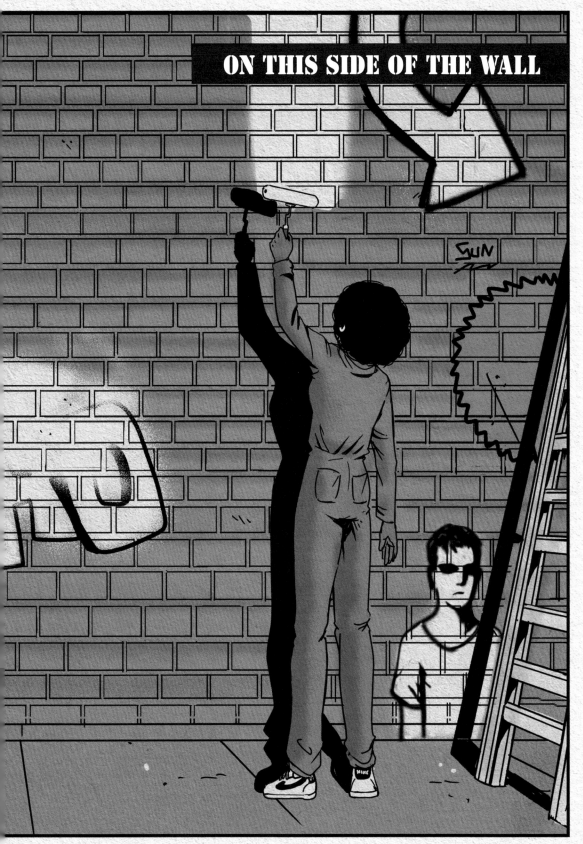

ON THIS SIDE OF THE WALL

LONDON

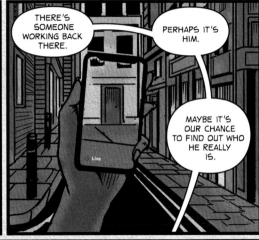

THERE'S SOMEONE WORKING BACK THERE.

PERHAPS IT'S HIM.

MAYBE IT'S OUR CHANCE TO FIND OUT WHO HE REALLY IS.

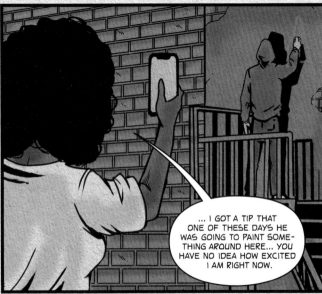

... I GOT A TIP THAT ONE OF THESE DAYS HE WAS GOING TO PAINT SOME-THING AROUND HERE... YOU HAVE NO IDEA HOW EXCITED I AM RIGHT NOW.

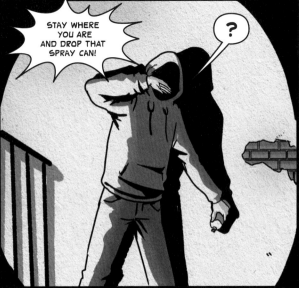

STAY WHERE YOU ARE AND DROP THAT SPRAY CAN!

?

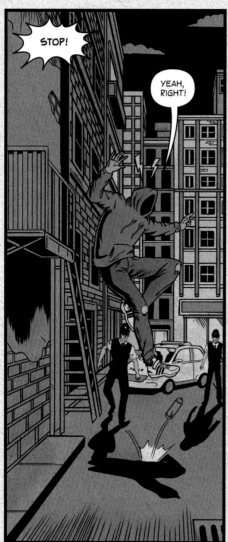

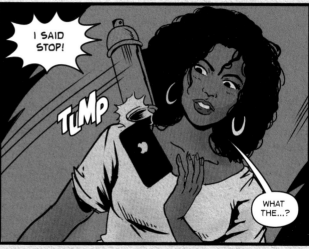

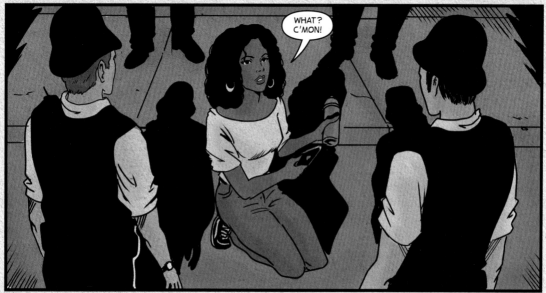

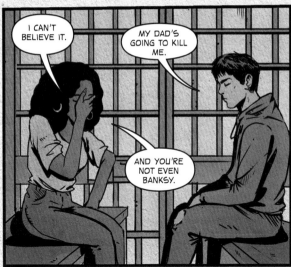

I CAN'T BELIEVE IT.

MY DAD'S GOING TO KILL ME.

AND YOU'RE NOT EVEN BANKSY.

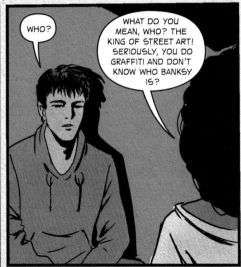

WHO?

WHAT DO YOU MEAN, WHO? THE KING OF STREET ART! SERIOUSLY, YOU DO GRAFFITI AND DON'T KNOW WHO BANKSY IS?

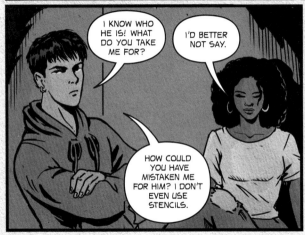

I KNOW WHO HE IS! WHAT DO YOU TAKE ME FOR?

I'D BETTER NOT SAY.

HOW COULD YOU HAVE MISTAKEN ME FOR HIM? I DON'T EVEN USE STENCILS.

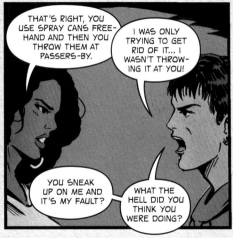

THAT'S RIGHT, YOU USE SPRAY CANS FREE-HAND AND THEN YOU THROW THEM AT PASSERS-BY.

I WAS ONLY TRYING TO GET RID OF IT... I WASN'T THROW-ING IT AT YOU!

YOU SNEAK UP ON ME AND IT'S MY FAULT?

WHAT THE HELL DID YOU THINK YOU WERE DOING?

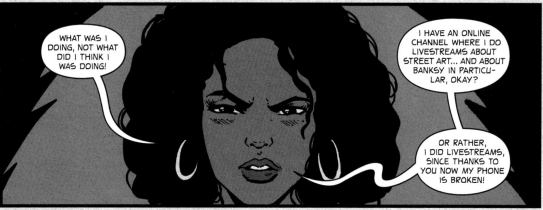

WHAT WAS I DOING, NOT WHAT DID I THINK I WAS DOING!

I HAVE AN ONLINE CHANNEL WHERE I DO LIVESTREAMS ABOUT STREET ART... AND ABOUT BANKSY IN PARTICULAR, OKAY?

OR RATHER, I DID LIVESTREAMS, SINCE THANKS TO YOU NOW MY PHONE IS BROKEN!

WOULD YOU STOP BLAMING ME?

THEY'LL MAKE US DO COMMUNITY SERVICE, I KNOW IT.

NAH...

THEY THINK I'M YOUR AC-COMPLICE!

ACCOMPLICE? ISN'T THAT KIND OF A STRONG WORD?

I BET THEY'LL MAKE US CLEAN GRAFFITI FROM THE CITY WALLS.

OH, STOP!

LISTEN... IF THEY MAKE ME DO SOMETHING BECAUSE OF YOUR STUPIDITY, TO REPAY ME YOU'LL HELP ME WITH MY RESEARCH, OKAY?

GOT IT?

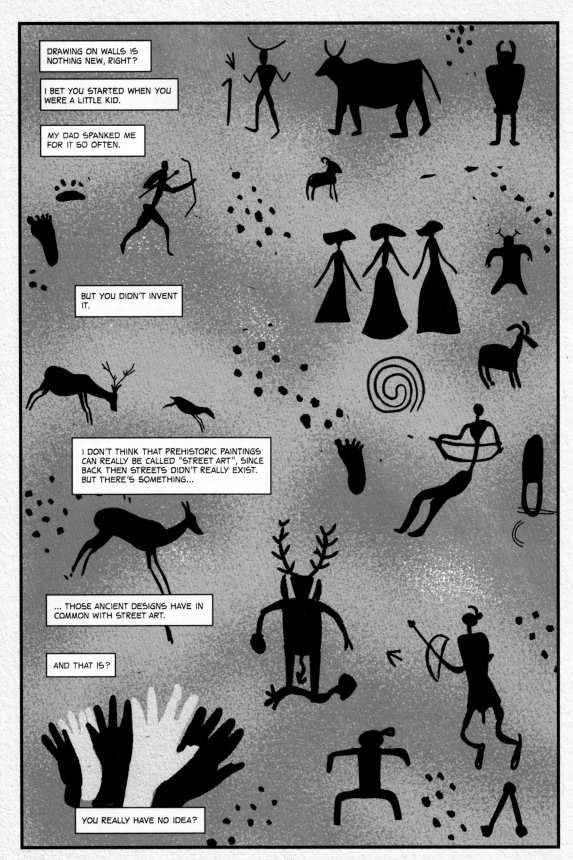

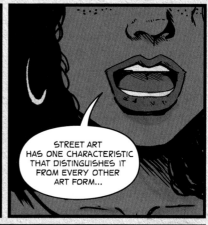

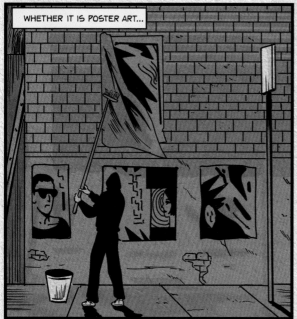

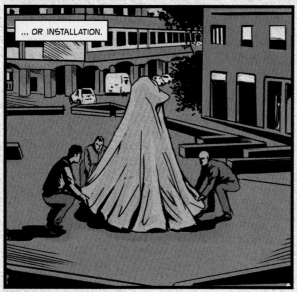

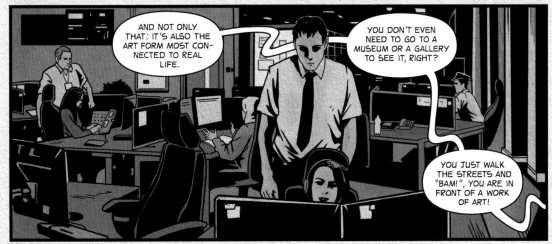

AND SINCE, AS YOU SAID, IT IS ILLEGAL, THE SPEED OF EXECUTION IS OF UTMOST IMPORTANCE.

SO MUCH SO THAT IN MANY CASES ARTISTS HANG PRE-PREPARED POSTERS OR USE STENCILS, WHICH ALLOWS THEM TO MAKE THE DRAWING VERY QUICKLY.

THE PRE-PRODUCTION, ON THE OTHER HAND, CAN TAKE A LONG TIME.

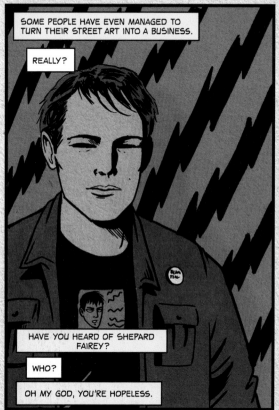

SOME PEOPLE HAVE EVEN MANAGED TO TURN THEIR STREET ART INTO A BUSINESS.

REALLY?

HAVE YOU HEARD OF SHEPARD FAIREY?

WHO?

OH MY GOD, YOU'RE HOPELESS.

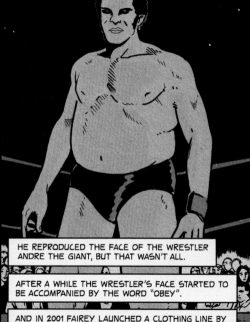

HE'S AN AMERICAN ARTIST... HE CREATED THE "ANDRE THE GIANT HAS A POSSE" CAMPAIGN IN THE LATE 1980S.

HE REPRODUCED THE FACE OF THE WRESTLER ANDRE THE GIANT, BUT THAT WASN'T ALL.

AFTER A WHILE THE WRESTLER'S FACE STARTED TO BE ACCOMPANIED BY THE WORD "OBEY".

AND IN 2001 FAIREY LAUNCHED A CLOTHING LINE BY THAT NAME... YOU MUST KNOW IT.

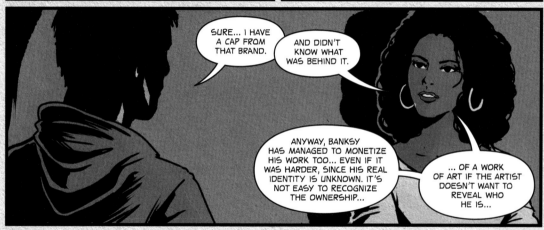

SURE... I HAVE A CAP FROM THAT BRAND.

AND DIDN'T KNOW WHAT WAS BEHIND IT.

ANYWAY, BANKSY HAS MANAGED TO MONETIZE HIS WORK TOO... EVEN IF IT WAS HARDER, SINCE HIS REAL IDENTITY IS UNKNOWN. IT'S NOT EASY TO RECOGNIZE THE OWNERSHIP...

... OF A WORK OF ART IF THE ARTIST DOESN'T WANT TO REVEAL WHO HE IS...

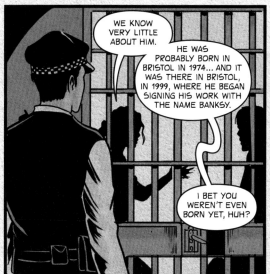

WE KNOW VERY LITTLE ABOUT HIM.

HE WAS PROBABLY BORN IN BRISTOL IN 1974... AND IT WAS THERE IN BRISTOL, IN 1999, WHERE HE BEGAN SIGNING HIS WORK WITH THE NAME BANKSY.

I BET YOU WEREN'T EVEN BORN YET, HUH?

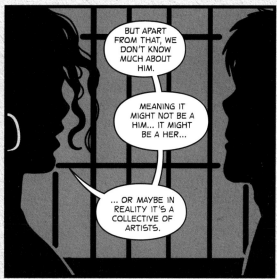

BUT APART FROM THAT, WE DON'T KNOW MUCH ABOUT HIM.

MEANING IT MIGHT NOT BE A HIM... IT MIGHT BE A HER...

... OR MAYBE IN REALITY IT'S A COLLECTIVE OF ARTISTS.

CLANG

ADAM AND CLAIRE, THAT'S YOU TWO, RIGHT? COME ON, YOU'RE NEXT.

POLICE

C'MON, WE'LL BE OUT OF HERE SOON.

WELL, NOW YOU KNOW OUR DEAL.

OUR DEAL? WHAT DO YOU MEAN?

IF THEY MAKE US DO COMMUNITY SERVICE, YOU'LL HELP ME WITH MY RESEARCH... YOU NEED TO KNOW SOMETHING BEFORE STARTING, RIGHT?

COME ON...

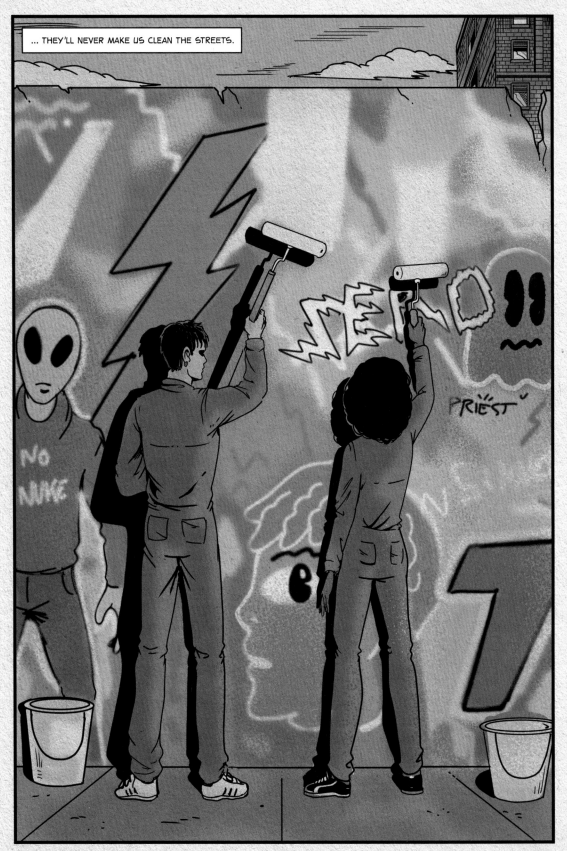

ART VERSUS THE MULTINATIONALS

GOT IT?

YEAH, I GOT IT.

SO GIVE ME YOUR PHONE.

MY...?

GO ON!

IN CASE YOU DIDN'T UNDERSTAND: BETWEEN US TWO I'M THE ONE IN CHARGE.

ALSO BECAUSE IF YOU WERE IN CHARGE, YOU COULD PUT US BEHIND BARS FOR LIFE.

HEY!

YOU BROKE MY PHONE, SO UNTIL THEY FIX MINE, I'M USING YOURS. ALL WE NEED TO DO IS SEE IF IT WORKS OKAY FOR VIDEOS.

GO ON, REPEAT EVERYTHING I JUST SAID TO YOU.

OH... OKAY...

... SO, BANKSY...

DON'T BE SHY. HERE IT'S JUST YOU AND ME AND YOUR SMARTPHONE.

... THE FIRST PIECE SIGNED BY BANKSY THAT WE KNOW OF APPEARED IN BRISTOL IN 1999.

IT'S CALLED *THE MILD MILD WEST* AND IT DEPICTS A TEDDY BEAR THROWING A MOLOTOV COCKTAIL AT SEVERAL POLICEMEN IN RIOT GEAR.

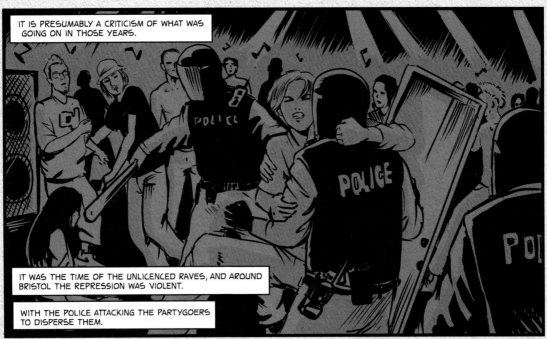

IT IS PRESUMABLY A CRITICISM OF WHAT WAS GOING ON IN THOSE YEARS.

IT WAS THE TIME OF THE UNLICENCED RAVES, AND AROUND BRISTOL THE REPRESSION WAS VIOLENT.

WITH THE POLICE ATTACKING THE PARTYGOERS TO DISPERSE THEM.

MORE THAN 20 YEARS LATER, THE MURAL IS STILL IN ITS ORIGINAL LOCATION... SINCE THEN IT HAS BEEN DAMAGED AND RESTORED, AND DESPITE ALL THE CONTROVERSY IT IS NOW CONSIDERED BY MOST TO BE A CITY TREASURE...

BUT THEN BANKSY BECAME ACTIVE IN LONDON, EXPANDING HIS CRITICAL WORK TO MUCH MORE GLOBAL THEMES.

BUT YOU ONLY TOLD ME A LITTLE BIT ABOUT THAT, SO I DON'T KNOW WHAT ELSE TO SAY.

HA HA HA!

GREAT CLOSING!

BUT...

... YOU'RE PRETTY GOOD AT TALKING IN FRONT OF THE CAMERA.

YOU'LL BE USEFUL FOR THE NEXT VIDEOS.

WHAT DO YOU SAY IF I UPLOAD THIS ONE TO THE CHANNEL?

DO AS YOU LIKE.

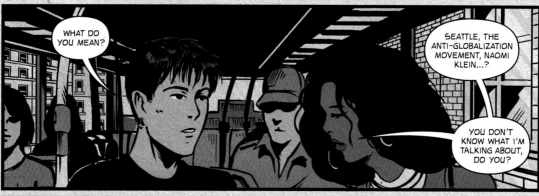

24

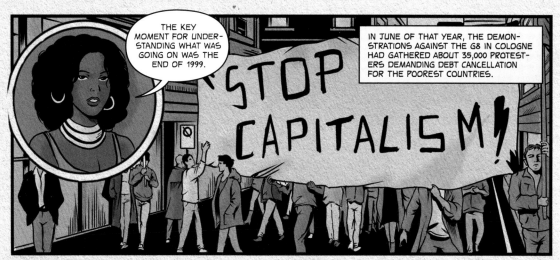

THE KEY MOMENT FOR UNDERSTANDING WHAT WAS GOING ON WAS THE END OF 1999.

IN JUNE OF THAT YEAR, THE DEMONSTRATIONS AGAINST THE G8 IN COLOGNE HAD GATHERED ABOUT 35,000 PROTESTERS DEMANDING DEBT CANCELLATION FOR THE POOREST COUNTRIES.

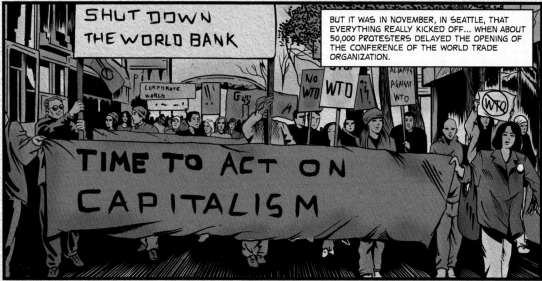

SHUT DOWN THE WORLD BANK

BUT IT WAS IN NOVEMBER, IN SEATTLE, THAT EVERYTHING REALLY KICKED OFF... WHEN ABOUT 50,000 PROTESTERS DELAYED THE OPENING OF THE CONFERENCE OF THE WORLD TRADE ORGANIZATION.

TIME TO ACT ON CAPITALISM

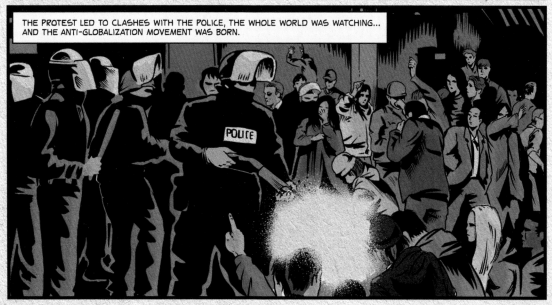

THE PROTEST LED TO CLASHES WITH THE POLICE, THE WHOLE WORLD WAS WATCHING... AND THE ANTI-GLOBALIZATION MOVEMENT WAS BORN.

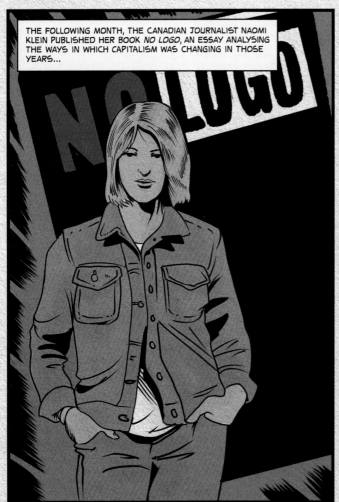

THE FOLLOWING MONTH, THE CANADIAN JOURNALIST NAOMI KLEIN PUBLISHED HER BOOK *NO LOGO*, AN ESSAY ANALYSING THE WAYS IN WHICH CAPITALISM WAS CHANGING IN THOSE YEARS...

... AN ACCUSATION AGAINST THE BIG INTERNATIONAL BRANDS, WHO WERE READY TO OUTSOURCE THEIR PRODUCTION TO ASIA AND SOUTH AMERICA TO REDUCE COSTS, WITHOUT ANY CONCERN FOR THE CONDITIONS OF THE WORKERS...

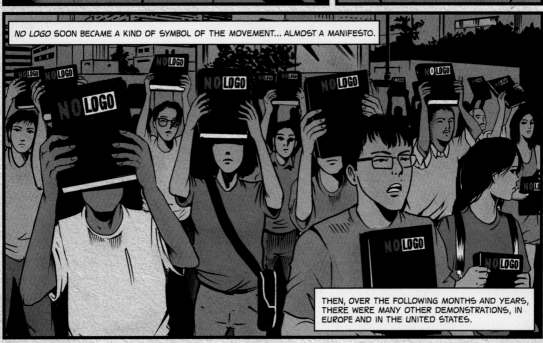

NO LOGO SOON BECAME A KIND OF SYMBOL OF THE MOVEMENT... ALMOST A MANIFESTO.

THEN, OVER THE FOLLOWING MONTHS AND YEARS, THERE WERE MANY OTHER DEMONSTRATIONS, IN EUROPE AND IN THE UNITED STATES.

YAAAWNNNN!

I CAN SEE YOU'RE REALLY INTERESTED.

NO, NO... I'M INTERESTED.

BUT I DON'T UNDERSTAND WHAT IT HAS TO DO WITH YOUR RESEARCH.

IT'S OUR RESEARCH NOW!

ANTI-CAPITALISM, THE ANTI-WAR MOVEMENT, ANTI-GLOBALIZATION... THESE ARE ALL TOPICS THAT ALSO APPEAR IN THE WORK OF BANKSY.

AND MAYBE UNDER-STANDING THE SOCIO-POLITICAL CONTEXT OVERALL WILL HELP US TO UNDERSTAND HIM BETTER, TOO.

FOR INSTANCE, DO YOU REMEMBER *FLOWER THROWER*? THAT MURAL OF BANKSY'S FEATURING A DEMON-STRATOR THROWING A BUNCH OF FLOWERS?

OF COURSE I DO!

GOOD.

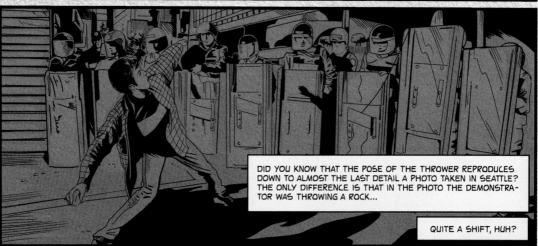

DID YOU KNOW THAT THE POSE OF THE THROWER REPRODUCES DOWN TO ALMOST THE LAST DETAIL A PHOTO TAKEN IN SEATTLE? THE ONLY DIFFERENCE IS THAT IN THE PHOTO THE DEMONSTRA-TOR WAS THROWING A ROCK...

QUITE A SHIFT, HUH?

WHAT'S UP?

WE'RE SAFE IN THESE FRONT SEATS, RIGHT? I MEAN, TOTALLY SAFE?

YET IF I LOOK DOWN, I FEEL LIKE I'M ABOUT TO FALL DOWN INTO THE VOID UNTIL I CRASH INTO THE ASPHALT...

... SAFE AND IN DANGER AT THE SAME TIME.

IT'S KIND OF THE SAME FEELING THAT I GET FROM LISTENING TO YOU TALK.

WHY DO YOU DO GRAFFITI?

UMM...

... BECAUSE IT'S FUN, I THINK.

GRAFFITI IS COM-MUNICATION.

WHAT DO YOU WANT TO COM-MUNICATE?

I JUST WANT TO DO MY DRAWINGS.

FOR THAT YOU COULD STAY IN YOUR ROOM AND PLAY WITH PAINT-BRUSHES.

NO, YOU WANT EVERYONE TO SEE YOUR DRAWINGS.

ARE YOU SAYING I'M AN EXHIBITIONIST?

HA! HA!

NO.

MAYBE.

SHE'S A VIETNAMESE WOMAN, NEARLY 60, AND A UNESCO AMBASSADOR.

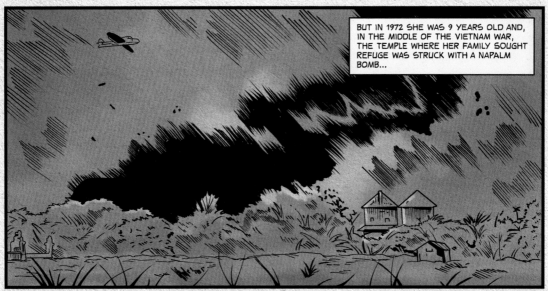

BUT IN 1972 SHE WAS 9 YEARS OLD AND, IN THE MIDDLE OF THE VIETNAM WAR, THE TEMPLE WHERE HER FAMILY SOUGHT REFUGE WAS STRUCK WITH A NAPALM BOMB...

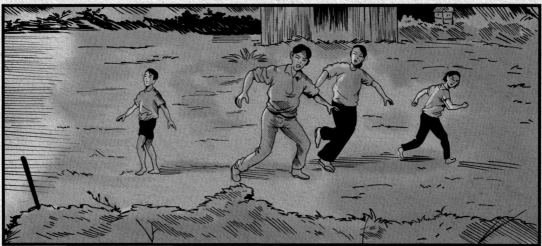

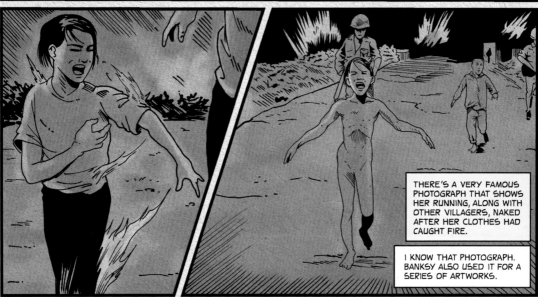

THERE'S A VERY FAMOUS PHOTOGRAPH THAT SHOWS HER RUNNING, ALONG WITH OTHER VILLAGERS, NAKED AFTER HER CLOTHES HAD CAUGHT FIRE.

I KNOW THAT PHOTOGRAPH. BANKSY ALSO USED IT FOR A SERIES OF ARTWORKS.

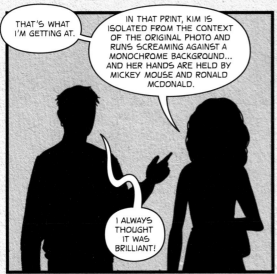

THAT'S WHAT I'M GETTING AT.

IN THAT PRINT, KIM IS ISOLATED FROM THE CONTEXT OF THE ORIGINAL PHOTO AND RUNS SCREAMING AGAINST A MONOCHROME BACKGROUND... AND HER HANDS ARE HELD BY MICKEY MOUSE AND RONALD MCDONALD.

I ALWAYS THOUGHT IT WAS BRILLIANT!

AND WHY?

UMM... IT'S ABSURD.

IT PUTS RANDOM THINGS TO-GETHER.

SURE, IT'S A PARADOXICAL IMAGE.

BUT TRY TO THINK.

WHO DID ALL THE WORST STUFF IN THE VIETNAM WAR?

THE UNITED STATES?

AND FOR WHAT COUNTRY DO MICKEY AND MCDONALD'S RE-PRESENT THE SYM-BOLS OF CON-SUMERISM?

AGAIN, THE...

... OH!

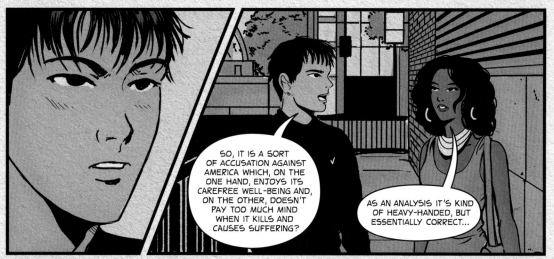

SO, IT IS A SORT OF ACCUSATION AGAINST AMERICA WHICH, ON THE ONE HAND, ENJOYS ITS CAREFREE WELL-BEING AND, ON THE OTHER, DOESN'T PAY TOO MUCH MIND WHEN IT KILLS AND CAUSES SUFFERING?

AS AN ANALYSIS IT'S KIND OF HEAVY-HANDED, BUT ESSENTIALLY CORRECT...

... EVEN IF, INSTEAD OF BEING DIRECTED AT AMERICA AS SUCH, THE CRITICISM IS PROBABLY DIRECTED MORE GENERALLY AGAINST CAPITALISM AND GLOBALIZATION.

AT THE BIG CORPORATIONS THAT EXPLOIT EVERYTHING THEY CAN TO INCREASE THEIR PROFIT...

... AND WHO HIDE THEIR QUESTIONABLE ETHICS BEHIND A COMMUNICATION STRATEGY OF CLOWNS AND OTHER AMUSING CHARACTERS.

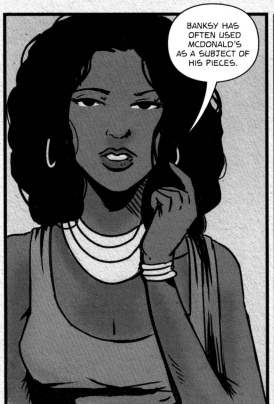

BANKSY HAS OFTEN USED MCDONALD'S AS A SUBJECT OF HIS PIECES.

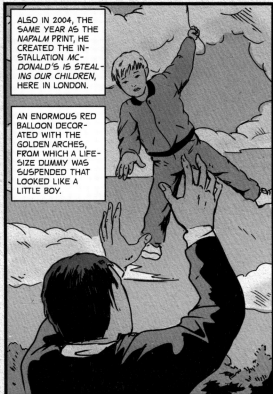

ALSO IN 2004, THE SAME YEAR AS THE *NAPALM* PRINT, HE CREATED THE IN-STALLATION *MC-DONALD'S IS STEAL-ING OUR CHILDREN,* HERE IN LONDON.

AN ENORMOUS RED BALLOON DECOR-ATED WITH THE GOLDEN ARCHES, FROM WHICH A LIFE-SIZE DUMMY WAS SUSPENDED THAT LOOKED LIKE A LITTLE BOY.

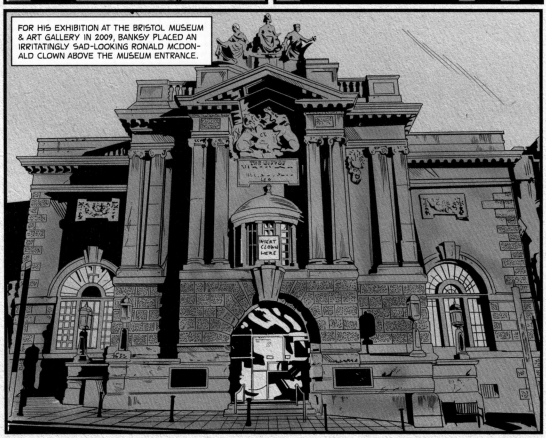

FOR HIS EXHIBITION AT THE BRISTOL MUSEUM & ART GALLERY IN 2009, BANKSY PLACED AN IRRITATINGLY SAD-LOOKING RONALD MCDON-ALD CLOWN ABOVE THE MUSEUM ENTRANCE.

IN 2013, THEN, THERE'S A SORT OF PERFORMANCE PIECE, AS PART OF THE PROJECT *BETTER OUT THAN IN*, IN NEW YORK...

... IN WHICH, IN FRONT OF A RESTAUR-ANT BELONGING TO THE CHAIN, AN ACTOR DRESSED AS A SHOESHINE BOY POLISHES RONALD MCDONALD'S CLOWN SHOES.

THEY'RE ALL CRITICISMS OF THE EXPLOITATION AND VIOLENCE OF THE BIG BRANDS, WHO ENTER OUR LIVES WITHOUT PERMISSION, PROSPER FROM THE MISERY OF OTHERS, AND DON'T RESPECT ANYTHING BUT MONEY...

EVER SINCE YOU FIRST MEN-TIONED MCDONALD'S I'VE BEEN CRAVING SOME FRIES...

... AND YOU AREN'T GOING TO MAKE ME FEEL GUILTY ABOUT IT!

ANYWAY, HERE WE ARE, WE'VE ARRIVED.

OH, YEAH? HERE IN THIS OLD STREET?

YOU'VE REALLY BROUGHT ME TO AN UN-FORGETTABLE SPOT, HAVEN'T YOU?

IDIOT!

FLAP

OW!

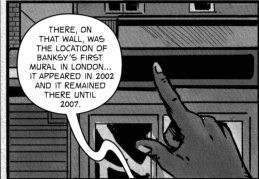

THERE, ON THAT WALL, WAS THE LOCATION OF BANKSY'S FIRST MURAL IN LONDON... IT APPEARED IN 2002 AND IT REMAINED THERE UNTIL 2007.

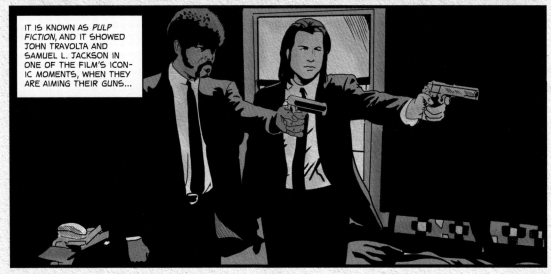

IT IS KNOWN AS *PULP FICTION*, AND IT SHOWED JOHN TRAVOLTA AND SAMUEL L. JACKSON IN ONE OF THE FILM'S ICON-IC MOMENTS, WHEN THEY ARE AIMING THEIR GUNS...

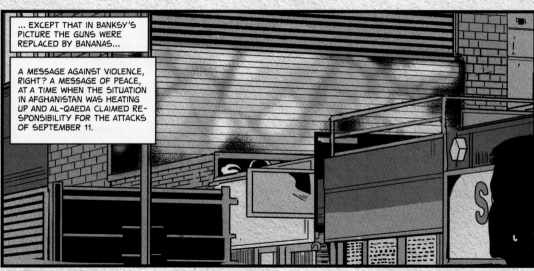

... EXCEPT THAT IN BANKSY'S PICTURE THE GUNS WERE REPLACED BY BANANAS...

A MESSAGE AGAINST VIOLENCE, RIGHT? A MESSAGE OF PEACE, AT A TIME WHEN THE SITUATION IN AFGHANISTAN WAS HEATING UP AND AL-QAEDA CLAIMED RE-SPONSIBILITY FOR THE ATTACKS OF SEPTEMBER 11.

WAIT A MINUTE.

YOU BROUGHT ME ALL THE WAY HERE JUST TO SEE A MURAL THAT'S NO LONGER HERE?

THIS SURPRISES YOU?

TRANSIENCE IS THE NATURE OF STREET ART.

AND ANYWAY, WE CAME HERE TO BREATHE THE AIR OF BANKSY'S EMERGENCE IN LONDON, EVEN IF WE'RE 20 YEARS LATE... NOT TO SEE "A MURAL THAT'S NO LONGER HERE".

GO ON, GIVE ME YOUR PHONE.

IT'S TIME TO RECORD YOUR SECOND VIDEO, HERE AT THE FORMER SITE OF *PULP FICTION*, AND TO TALK ABOUT THE RELATIONSHIP BETWEEN BANKSY AND THE MULTINATIONALS.

... I REALLY AM CRAVING SOME FRIES!

CHAPTER 2

ART VERSUS WALLS

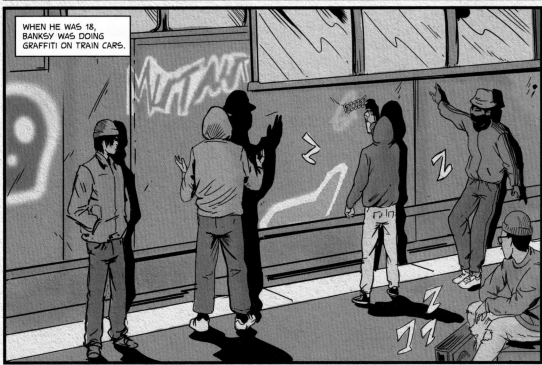

WHEN HE WAS 18, BANKSY WAS DOING GRAFFITI ON TRAIN CARS.

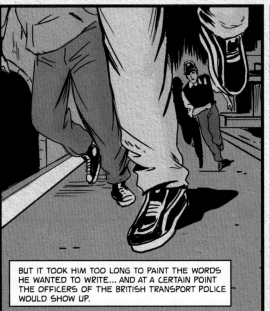

BUT IT TOOK HIM TOO LONG TO PAINT THE WORDS HE WANTED TO WRITE... AND AT A CERTAIN POINT THE OFFICERS OF THE BRITISH TRANSPORT POLICE WOULD SHOW UP.

CLASSIC.

SO HE HAD TO GET AWAY.

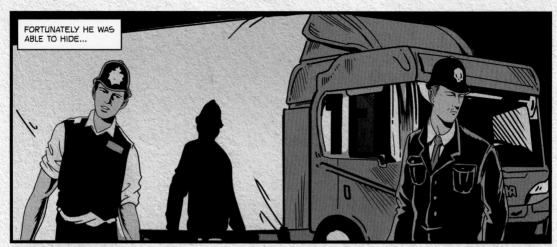

FORTUNATELY HE WAS ABLE TO HIDE...

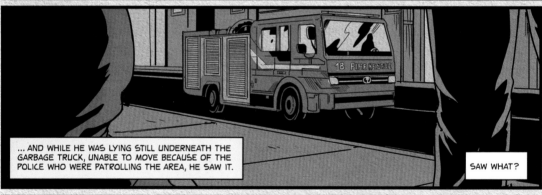

... AND WHILE HE WAS LYING STILL UNDERNEATH THE GARBAGE TRUCK, UNABLE TO MOVE BECAUSE OF THE POLICE WHO WERE PATROLLING THE AREA, HE SAW IT.

SAW WHAT?

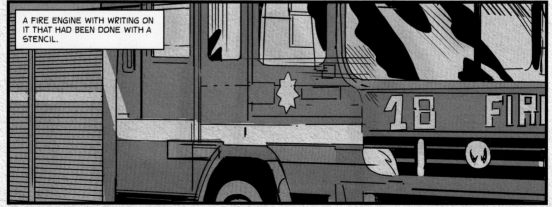

A FIRE ENGINE WITH WRITING ON IT THAT HAD BEEN DONE WITH A STENCIL.

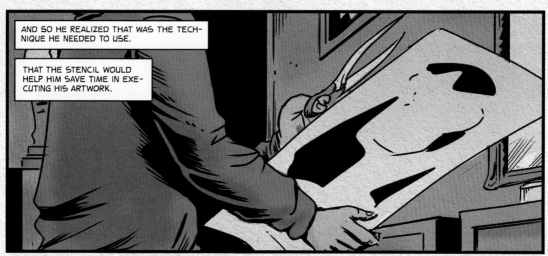

AND SO HE REALIZED THAT WAS THE TECH-NIQUE HE NEEDED TO USE.

THAT THE STENCIL WOULD HELP HIM SAVE TIME IN EXE-CUTING HIS ARTWORK.

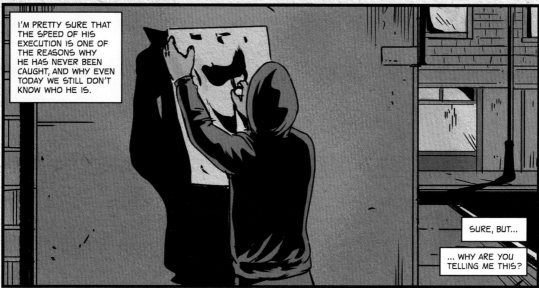

I'M PRETTY SURE THAT THE SPEED OF HIS EXECUTION IS ONE OF THE REASONS WHY HE HAS NEVER BEEN CAUGHT, AND WHY EVEN TODAY WE STILL DON'T KNOW WHO HE IS.

SURE, BUT...

... WHY ARE YOU TELLING ME THIS?

OH, THAT'S EASY...

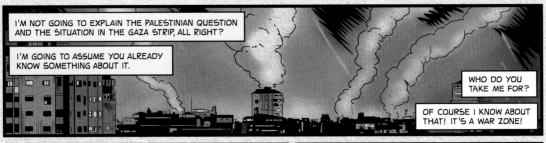

I'M NOT GOING TO EXPLAIN THE PALESTINIAN QUESTION AND THE SITUATION IN THE GAZA STRIP, ALL RIGHT?

I'M GOING TO ASSUME YOU ALREADY KNOW SOMETHING ABOUT IT.

WHO DO YOU TAKE ME FOR?

OF COURSE I KNOW ABOUT THAT! IT'S A WAR ZONE!

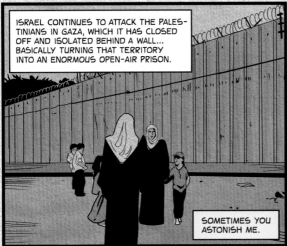

ISRAEL CONTINUES TO ATTACK THE PALESTINIANS IN GAZA, WHICH IT HAS CLOSED OFF AND ISOLATED BEHIND A WALL... BASICALLY TURNING THAT TERRITORY INTO AN ENORMOUS OPEN-AIR PRISON.

SOMETIMES YOU ASTONISH ME.

ANYWAY, YES... AND BETWEEN 2003 AND 2005, BANKSY WENT TO DO SOME GRAFFITI RIGHT THERE ON THAT WALL.

AND AT A CERTAIN POINT, AS HE TELLS IT, HE MET AN OLD MAN, A LOCAL.

YOU'VE MADE THE WALL BEAUTIFUL.

I'M GLAD YOU LIKE IT.

YOU DID NOT UNDERSTAND.

WE HATE THIS WALL, WE DON'T WANT IT TO BE BEAUTIFUL!

GET OUT OF HERE!

WELL, THAT'S UNDER-STANDABLE!

UM... WHEN YOU THINK ABOUT IT...

... SOMEONE GOES TO TRY TO DO SOMETHING GOOD, AND ALL HE RECEIVES ARE INSULTS.

MAYBE THAT'S WHY SOME 15 YEARS LATER, IN 2017, HE WENT BACK THERE AND OPENED THE WALLED OFF HOTEL.

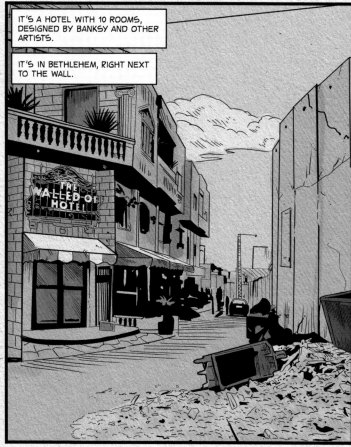

IT'S A HOTEL WITH 10 ROOMS, DESIGNED BY BANKSY AND OTHER ARTISTS.

IT'S IN BETHLEHEM, RIGHT NEXT TO THE WALL.

49

THE BAR IS FURNISHED IN THE STYLE OF AND WITH MEMORABILIA FROM THE CO-LONIAL ERA... THAT IS, FROM WHEN THE ENGLISH TOOK CONTROL OF PALESTINE.

ON THE WALL OF ONE OF THE ROOMS THERE ARE PAINTINGS OF AN ISRAELI SOLDIER AND A PALESTINIAN HAVING A PILLOW FIGHT, WITH FEATHERS FLYING EVERYWHERE.

FUNNY.

DRAMATIC... BUT ALSO FUNNY, YES.

THE CONTRAST BE-TWEEN DRAMA AND IRONY IS ONE OF THE THINGS THAT FASCIN-ATE ME MOST ABOUT BANKSY.

STREET ART COMES FROM BE-LOW.

BY ITS NATURE IT IS FAR REMOVED FROM THE LOGIC OF POWER AND COMMERCE...

... AND SO IT'S PRETTY OBVIOUS THAT AMONG ITS MESSAGES IS THE DENUNCIATION OF INEQUALITIES.

LIKE THE WORKS AT THE ISRAELI-PALESTINIAN BORDER YOU MENTIONED EARLIER.

ACTUALLY, IT'S A VERY BROAD DISCUSSION.

EVEN WHAT WE WERE SAYING ABOUT THE ENORMOUS POWER OF THE MULTINATIONALS AND THE EXPLOITATION OF THE WEAK IS RELATED TO THIS.

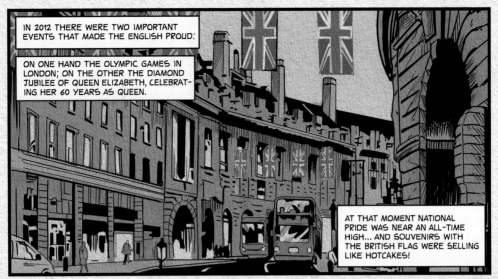

IN 2012 THERE WERE TWO IMPORTANT EVENTS THAT MADE THE ENGLISH PROUD:

ON ONE HAND THE OLYMPIC GAMES IN LONDON; ON THE OTHER THE DIAMOND JUBILEE OF QUEEN ELIZABETH, CELEBRATING HER 60 YEARS AS QUEEN.

AT THAT MOMENT NATIONAL PRIDE WAS NEAR AN ALL-TIME HIGH... AND SOUVENIRS WITH THE BRITISH FLAG WERE SELLING LIKE HOTCAKES!

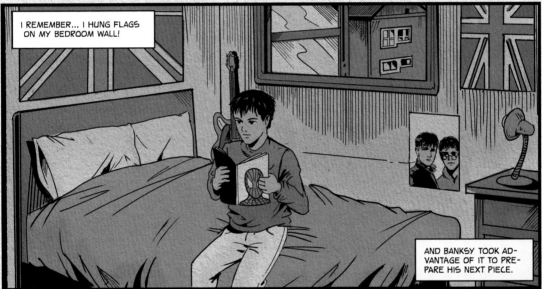

I REMEMBER... I HUNG FLAGS ON MY BEDROOM WALL!

AND BANKSY TOOK ADVANTAGE OF IT TO PREPARE HIS NEXT PIECE.

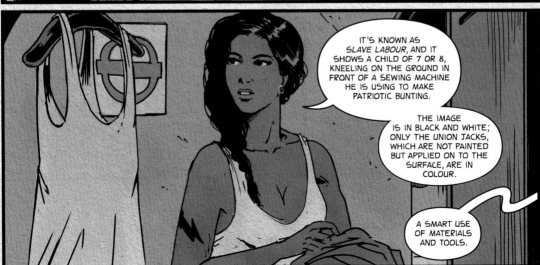

IT'S KNOWN AS SLAVE LABOUR, AND IT SHOWS A CHILD OF 7 OR 8, KNEELING ON THE GROUND IN FRONT OF A SEWING MACHINE HE IS USING TO MAKE PATRIOTIC BUNTING.

THE IMAGE IS IN BLACK AND WHITE; ONLY THE UNION JACKS, WHICH ARE NOT PAINTED BUT APPLIED ON TO THE SURFACE, ARE IN COLOUR.

A SMART USE OF MATERIALS AND TOOLS.

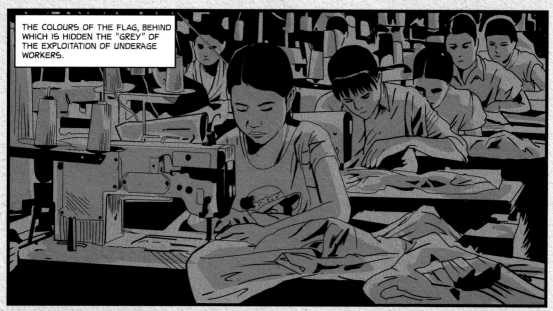

THE COLOURS OF THE FLAG, BEHIND WHICH IS HIDDEN THE "GREY" OF THE EXPLOITATION OF UNDERAGE WORKERS.

THAT MEANS... IN ART THE CHOICE OF TOOLS AND MATERIALS IS NEVER RANDOM... IT HAS MEANING.

WHAT'S THE MATTER?

NOTHING.

IT'S THAT SOMETIMES YOU SEEM LESS STUPID THAN I THOUGHT.

DOESN'T SOUND LIKE A COMPLIMENT.

IT ISN'T.

ANYWAY, *SLAVE LABOUR* APPEARED IN MAY OF 2012 ON A WALL AT WOOD GREEN... ABOUT TWO MONTHS BEFORE THE START OF THE OLYMPICS.

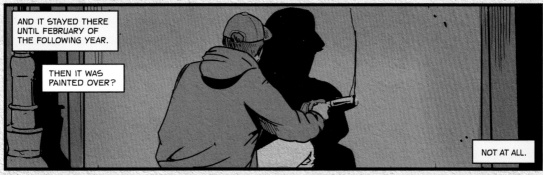

AND IT STAYED THERE UNTIL FEBRUARY OF THE FOLLOWING YEAR.

THEN IT WAS PAINTED OVER?

NOT AT ALL.

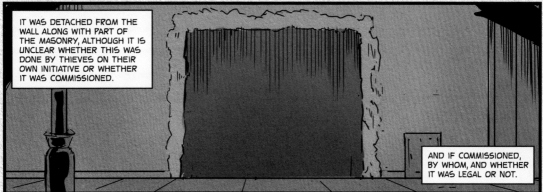

IT WAS DETACHED FROM THE WALL ALONG WITH PART OF THE MASONRY, ALTHOUGH IT IS UNCLEAR WHETHER THIS WAS DONE BY THIEVES ON THEIR OWN INITIATIVE OR WHETHER IT WAS COMMISSIONED.

AND IF COMMISSIONED, BY WHOM, AND WHETHER IT WAS LEGAL OR NOT.

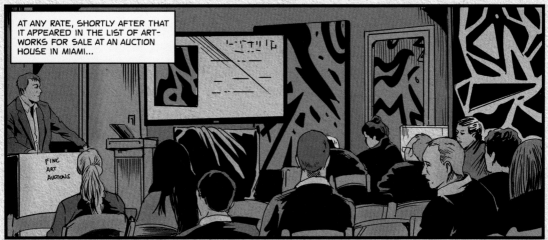

AT ANY RATE, SHORTLY AFTER THAT IT APPEARED IN THE LIST OF ART-WORKS FOR SALE AT AN AUCTION HOUSE IN MIAMI...

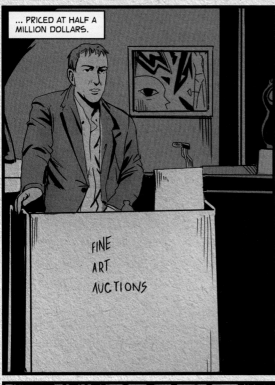

... PRICED AT HALF A MILLION DOLLARS.

FINE ART AUCTIONS

THE RESIDENTS OF WOOD GREEN PROTESTED, CLAIMING THAT THE ENTIRE AFFAIR REPRESENTED A THEFT FROM THEM... EVEN IF THE AUCTION HOUSE SUSTAINED THAT THE ACQUISITION HAD BEEN COMPLETELY LEGITIMATE.

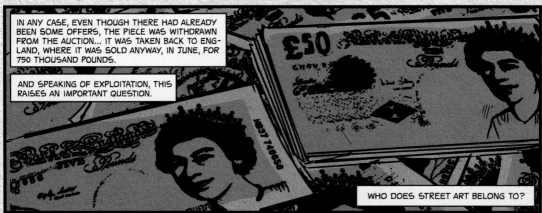

IN ANY CASE, EVEN THOUGH THERE HAD ALREADY BEEN SOME OFFERS, THE PIECE WAS WITHDRAWN FROM THE AUCTION... IT WAS TAKEN BACK TO ENGLAND, WHERE IT WAS SOLD ANYWAY, IN JUNE, FOR 750 THOUSAND POUNDS.

AND SPEAKING OF EXPLOITATION, THIS RAISES AN IMPORTANT QUESTION.

WHO DOES STREET ART BELONG TO?

TO THE ARTIST WHO CREATED IT?

TO THE COMMUNITY?

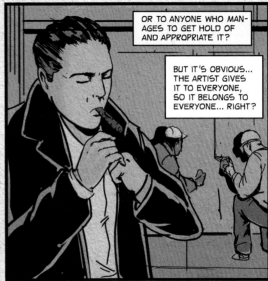

OR TO ANYONE WHO MANAGES TO GET HOLD OF AND APPROPRIATE IT?

BUT IT'S OBVIOUS... THE ARTIST GIVES IT TO EVERYONE, SO IT BELONGS TO EVERYONE... RIGHT?

FOLLOWING THAT LOGIC, YES... BUT EVIDENTLY, IN PRACTICE THINGS ARE MUCH MORE COMPLICATED.

HOW STRANGE.

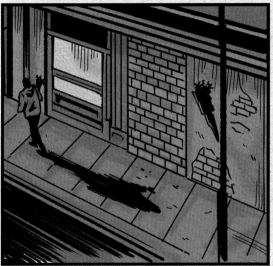

MORE THAN THE SCENT OF FLOWERS...

... I SMELL PLASTER.

CHAPTER 3

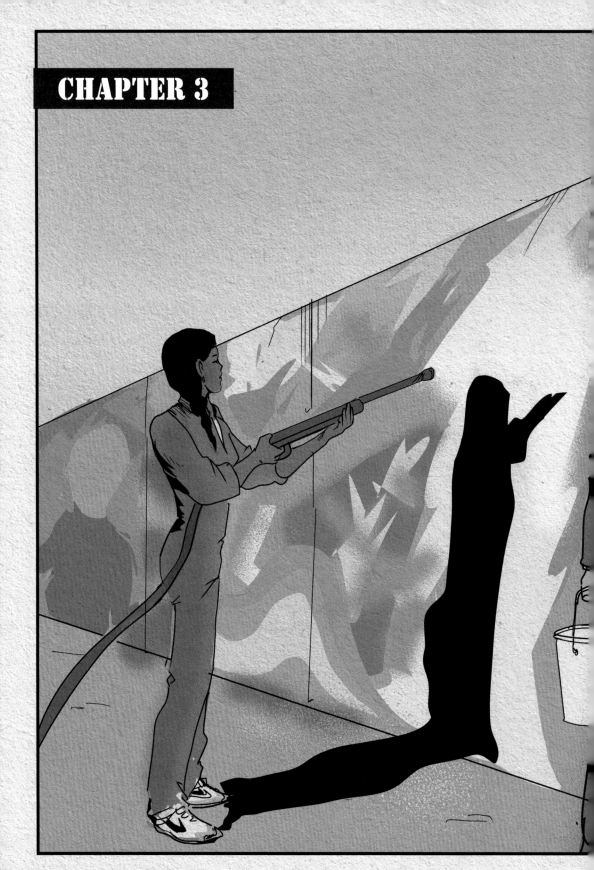

ART VERSUS COMPLACENCY

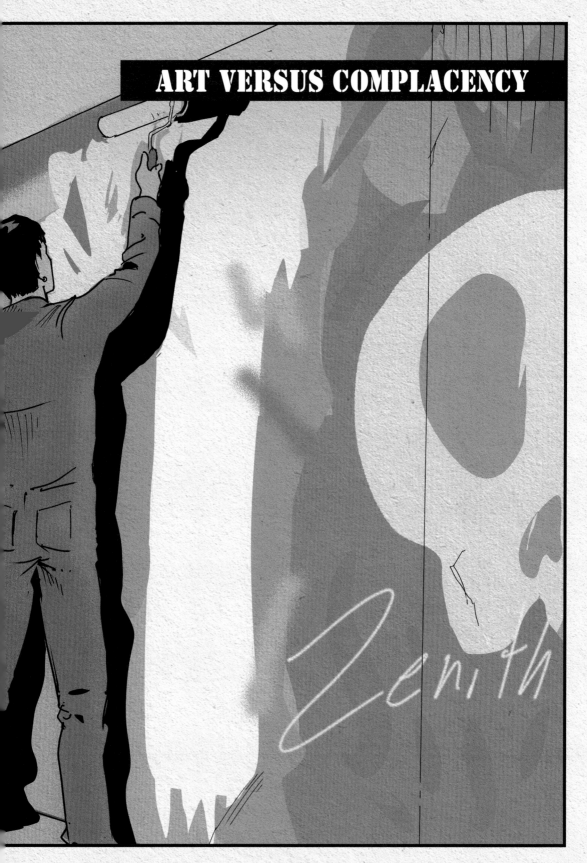

Zenith

I'VE BEEN STUDYING...

... WELL, READING SOME THINGS AND RE-FLECTING ON THEM.

YOU DIDN'T EXPECT THAT, DID YOU?

NOW I NO LONGER KNOW WHAT TO EXPECT.

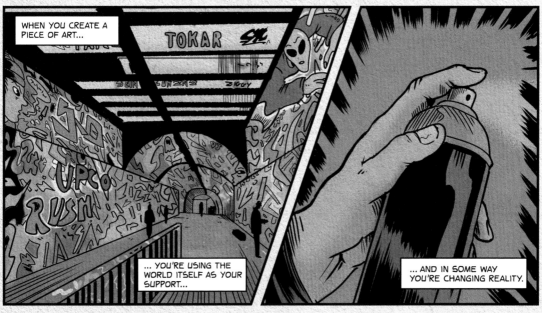

WHEN YOU CREATE A PIECE OF ART...

... YOU'RE USING THE WORLD ITSELF AS YOUR SUPPORT...

... AND IN SOME WAY YOU'RE CHANGING REALITY.

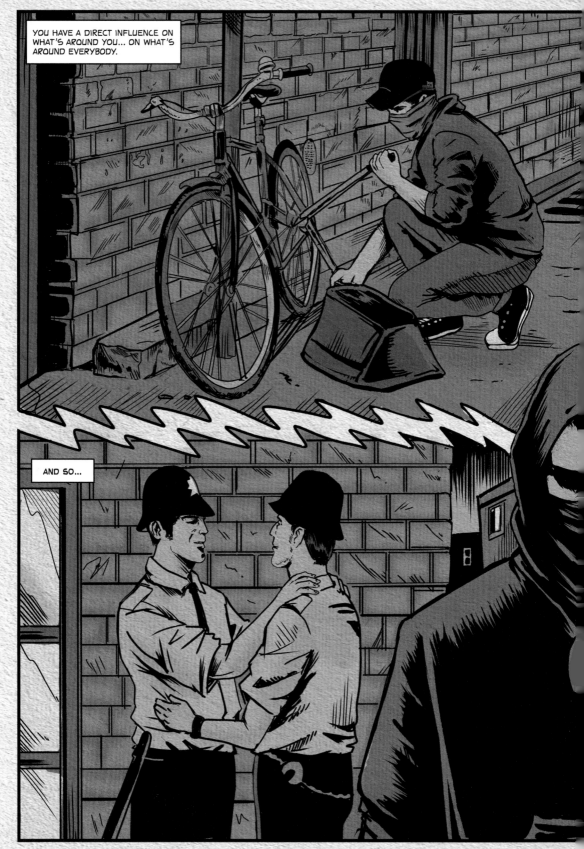

YOU HAVE A DIRECT INFLUENCE ON WHAT'S AROUND YOU... ON WHAT'S AROUND EVERYBODY.

AND SO...

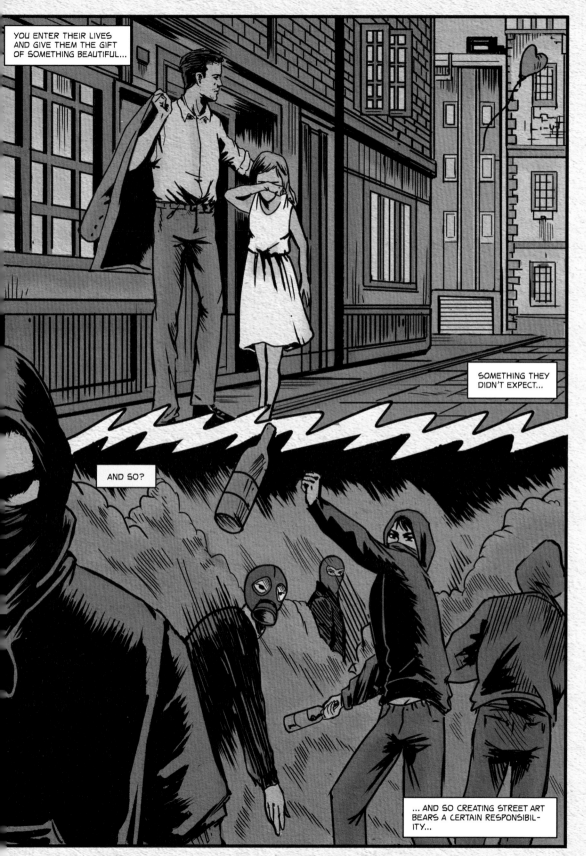

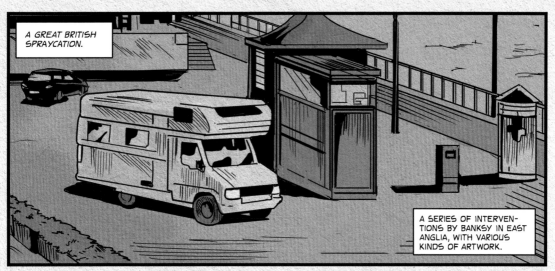

A GREAT BRITISH SPRAYCATION.

A SERIES OF INTERVENTIONS BY BANKSY IN EAST ANGLIA, WITH VARIOUS KINDS OF ARTWORK.

BUT I'M THINKING IN PARTICULAR OF WHAT HAPPENED TO ONE OF HIS STENCILLED MURALS.

IN LOWESTOFT, IN SUFFOLK, ALONG WITH A FEW OTHER PIECES, BANKSY CREATED A DESIGN OF A RAT RELAXING IN A DECKCHAIR, DRINKING A COCKTAIL...

BUT THEN SOMEONE COVERED IT OVER WITH A COAT OF WHITE PAINT. AND GUESS WHAT?

THERE BEGAN A SORT OF MANHUNT TO DISCOVER WHO HAD OBSCURED IT.

GET IT? YOU PAINT ON A WALL, SOMEONE PAINTS OVER IT, AND THAT'S WHO THE POLICE LOOK FOR.

AND THEY ARREST ME FOR DOING GRAFFITI.

YES... IN TRUTH, IF YOU THINK ABOUT IT THERE'S NO UNDERSTANDING THE LOGIC... OR RATHER, YOU UNDERSTAND IT, BUT IT'S CONTRADICTORY.

YOU SEE? ART DISTORTS RATIONALITY! IT DOESN'T CONFORM TO THE RULES WE KNOW!

IT'S GREAT TO DISTORT RATIONALITY!

I AGREE.

BANKSY OFTEN PLAYS WITH PEOPLE'S LOGIC AND INTELLIGENCE TO CREATE MENTAL SHORT CIRCUITS AND TO RAISE QUESTIONS.

FOR EXAMPLE, IT MAKES ME THINK OF *BARELY LEGAL*, THE SHOW HE ORGANIZED IN LOS ANGELES FROM 15 TO 17 SEPTEMBER 2006...

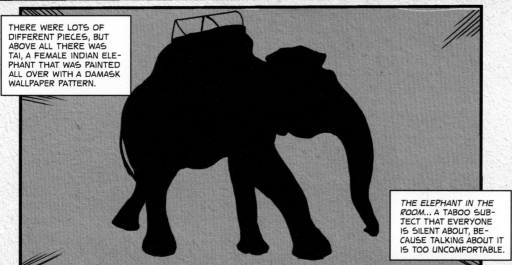

THERE WERE LOTS OF DIFFERENT PIECES, BUT ABOVE ALL THERE WAS TAI, A FEMALE INDIAN ELEPHANT THAT WAS PAINTED ALL OVER WITH A DAMASK WALLPAPER PATTERN.

THE ELEPHANT IN THE ROOM... A TABOO SUBJECT THAT EVERYONE IS SILENT ABOUT, BECAUSE TALKING ABOUT IT IS TOO UNCOMFORTABLE.

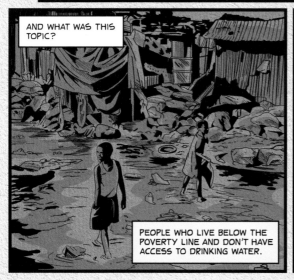

AND WHAT WAS THIS TOPIC?

PEOPLE WHO LIVE BELOW THE POVERTY LINE AND DON'T HAVE ACCESS TO DRINKING WATER.

IT WAS WRITTEN ON A CARD THAT WAS HANDED OUT TO VIEWERS AT THE ENTRANCE.

?

WHAT'S UP?

NOTHING... I THOUGHT I SAW...

... NEVER MIND, IT'S NOTHING... SOMETHING SILLY.

SO WE WERE TALKING ABOUT BANKSY'S MENTAL SHORT CIRCUITS. IN 2009 HE ORGANIZED A SHOW AT THE BRISTOL MUSEUM & ART GALLERY.

THE ONE WITH RONALD MCDONALD AT THE ENTRANCE?

YES, IT OPENED ON 15 JUNE AND WAS ON VIEW FOR ABOUT 3 MONTHS.

BANKSY MANAGED TO PERSUADE THE DIRECTORS OF THE MUSEUM TO GIVE HIM A SOLO EXHIBITION...

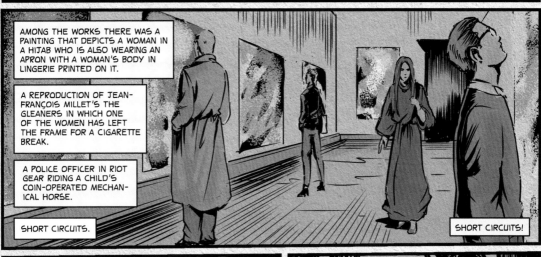

AMONG THE WORKS THERE WAS A PAINTING THAT DEPICTS A WOMAN IN A HIJAB WHO IS ALSO WEARING AN APRON WITH A WOMAN'S BODY IN LINGERIE PRINTED ON IT.

A REPRODUCTION OF JEAN-FRANÇOIS MILLET'S THE GLEANERS IN WHICH ONE OF THE WOMEN HAS LEFT THE FRAME FOR A CIGARETTE BREAK.

A POLICE OFFICER IN RIOT GEAR RIDING A CHILD'S COIN-OPERATED MECHANICAL HORSE.

SHORT CIRCUITS.

SHORT CIRCUITS!

I LIKE TO... TWIST THE MEANING OF THINGS IN ORDER TO FIND DEEPER SIGNIFICANCES... TO MAKE LOGIC DISAPPEAR TO FORCE THE VIEWER TO ABANDON THEIR USUAL PATTERNS OF THINKING.

YES, TO SEEM TO MAKE LOGIC DISAPPEAR!

EVERYTHING SEEMS ABSURD!

PERHAPS IT WOULD BE FUN TO MAKE A VIDEO ABOUT THE FAKE 10-POUND BANKNOTES DEPICTING PRINCESS DIANA.

FAKE, BUT WORTH MORE THAN THE REAL ONES!

YES... ON THE INTERNET THEY'RE GOING FOR AS MUCH AS SEVERAL THOUSAND POUNDS EACH.

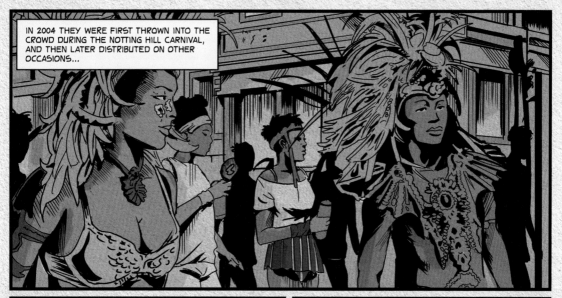

IN 2004 THEY WERE FIRST THROWN INTO THE CROWD DURING THE NOTTING HILL CARNIVAL, AND THEN LATER DISTRIBUTED ON OTHER OCCASIONS...

THEY SAY THAT SOME PEOPLE TRIED TO SPEND THEM, PROBABLY WITHOUT SUCCESS.

BUT THEY WERE LUCKY ENOUGH TO EXCHANGE THE NOTE FOR REAL MONEY.

EXACTLY.

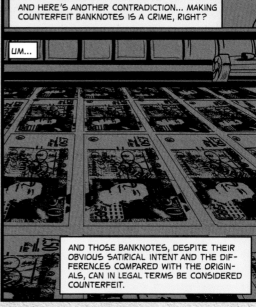

AND HERE'S ANOTHER CONTRADICTION... MAKING COUNTERFEIT BANKNOTES IS A CRIME, RIGHT?

UM...

AND THOSE BANKNOTES, DESPITE THEIR OBVIOUS SATIRICAL INTENT AND THE DIFFERENCES COMPARED WITH THE ORIGINALS, CAN IN LEGAL TERMS BE CONSIDERED COUNTERFEIT.

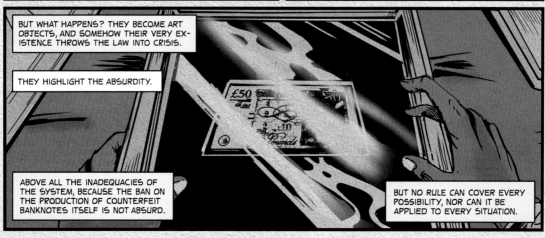

BUT WHAT HAPPENS? THEY BECOME ART OBJECTS, AND SOMEHOW THEIR VERY EXISTENCE THROWS THE LAW INTO CRISIS.

THEY HIGHLIGHT THE ABSURDITY.

ABOVE ALL THE INADEQUACIES OF THE SYSTEM, BECAUSE THE BAN ON THE PRODUCTION OF COUNTERFEIT BANKNOTES ITSELF IS NOT ABSURD.

BUT NO RULE CAN COVER EVERY POSSIBILITY, NOR CAN IT BE APPLIED TO EVERY SITUATION.

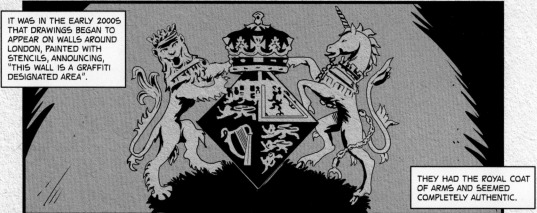

IT WAS IN THE EARLY 2000S THAT DRAWINGS BEGAN TO APPEAR ON WALLS AROUND LONDON, PAINTED WITH STENCILS, ANNOUNCING, "THIS WALL IS A GRAFFITI DESIGNATED AREA".

THEY HAD THE ROYAL COAT OF ARMS AND SEEMED COMPLETELY AUTHENTIC.

ABSURD AS THEY SEEMED, THEY HAD AN OFFICIAL AIR... AND AFTER ONLY A FEW HOURS THE WALLS AROUND THEM BEGAN FILLING UP WITH WRITING AND DRAWINGS.

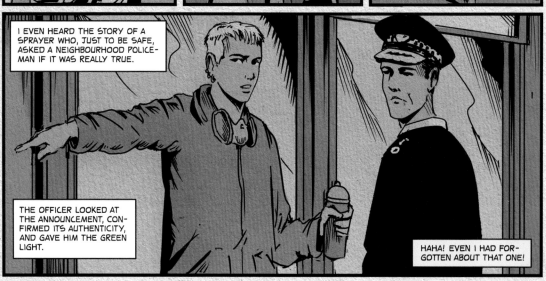

I EVEN HEARD THE STORY OF A SPRAYER WHO, JUST TO BE SAFE, ASKED A NEIGHBOURHOOD POLICEMAN IF IT WAS REALLY TRUE.

THE OFFICER LOOKED AT THE ANNOUNCEMENT, CONFIRMED ITS AUTHENTICITY, AND GAVE HIM THE GREEN LIGHT.

HAHA! EVEN I HAD FORGOTTEN ABOUT THAT ONE!

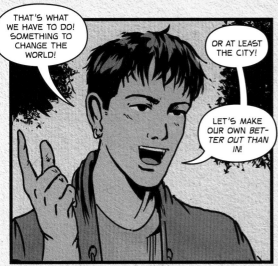

THAT'S WHAT WE HAVE TO DO! SOMETHING TO CHANGE THE WORLD!

OR AT LEAST THE CITY!

LET'S MAKE OUR OWN *BETTER OUT THAN IN!*

BETTER OUT THAN IN.

THE SERIES OF WORKS THAT...

I KNOW WHAT *BETTER OUT THAN IN* IS!

GOOD LORD, I'M THE ONE WHO ACTUALLY HAS A CLUE HERE.

IN OCTOBER 2013 BANKSY ORGANIZED A SORT OF "WANDERING SOLO SHOW" IN NEW YORK, ALTHOUGH I'M NOT SURE THAT'S THE MOST ACCURATE DEFINITION.

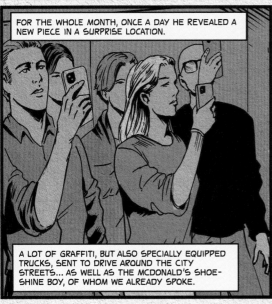

FOR THE WHOLE MONTH, ONCE A DAY HE REVEALED A NEW PIECE IN A SURPRISE LOCATION.

A LOT OF GRAFFITI, BUT ALSO SPECIALLY EQUIPPED TRUCKS, SENT TO DRIVE AROUND THE CITY STREETS... AS WELL AS THE MCDONALD'S SHOE-SHINE BOY, OF WHOM WE ALREADY SPOKE.

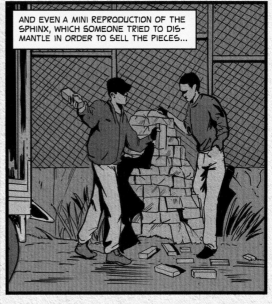

AND EVEN A MINI REPRODUCTION OF THE SPHINX, WHICH SOMEONE TRIED TO DIS-MANTLE IN ORDER TO SELL THE PIECES...

EXACTLY! SOMETHING LIKE THAT!

SOMETHING THAT STARTS A SORT OF TREAS-URE HUNT...

... THAT GETS PEOPLE INVOLVED AND MAKES THEM THINK!

WHAT'S UP?

LOOK...

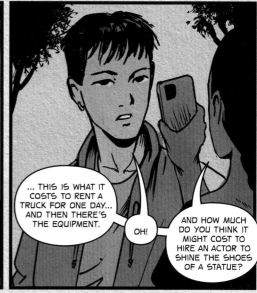

... THIS IS WHAT IT COSTS TO RENT A TRUCK FOR ONE DAY... AND THEN THERE'S THE EQUIPMENT.

OH!

AND HOW MUCH DO YOU THINK IT MIGHT COST TO HIRE AN ACTOR TO SHINE THE SHOES OF A STATUE?

OR TO CREATE THE TEMPLATES FOR THE STENCILS?

NOT TO MEN-TION THE RISK OF GETTING CAUGHT AGAIN!

YOU'RE TALKING ABOUT WHAT'S DOABLE, AND YOU DIDN'T CALL ME STUPID...

YOU LIKE THE IDEA!

LISTEN...

YOU LIKE IT!

ADAM!

YOU LIKE IT AND YOU CAN'T DENY IT!

PHEW!

COME ON, CLAIRE!

OKAY, I GOT CARRIED AWAY BY MY ENTHUSIASM BUT IT...

... WOULD BE DOPE, WOULDN'T IT?

CAN'T WE AT LEAST DREAM BIG?

IF YOU HAD DREAMED BIG, YOU WOULD NOT HAVE PROPOSED *BETTER OUT THAN IN* BUT...

... DISMALAND!

ACTUALLY, THAT WAS WHAT I HAD IN MIND, BUT I THOUGHT IT WAS A LITTLE TOO MUCH.

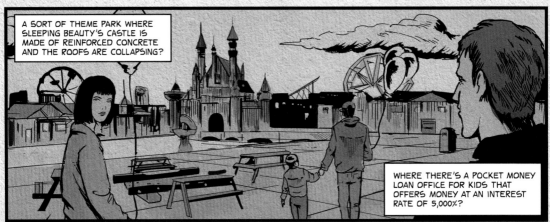

A SORT OF THEME PARK WHERE SLEEPING BEAUTY'S CASTLE IS MADE OF REINFORCED CONCRETE AND THE ROOFS ARE COLLAPSING?

WHERE THERE'S A POCKET MONEY LOAN OFFICE FOR KIDS THAT OFFERS MONEY AT AN INTEREST RATE OF 5,000%?

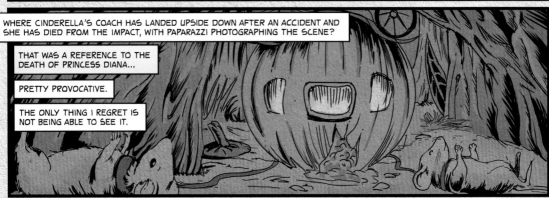

WHERE CINDERELLA'S COACH HAS LANDED UPSIDE DOWN AFTER AN ACCIDENT AND SHE HAS DIED FROM THE IMPACT, WITH PAPARAZZI PHOTOGRAPHING THE SCENE?

THAT WAS A REFERENCE TO THE DEATH OF PRINCESS DIANA...

PRETTY PROVOCATIVE.

THE ONLY THING I REGRET IS NOT BEING ABLE TO SEE IT.

IT WAS 2015, IN SOMERSET... NOT SO FAR REMOVED.

BUT FAR IN TERMS OF TIME! IN 2015 I DIDN'T EVEN KNOW I WAS INTERESTED IN ART!

AS FAR AS THAT GOES, YOU DIDN'T EVEN KNOW UP UNTIL A WEEK AGO!

ANYWAY, MORE THAN JUST A BANKSY SHOW, "DISMALAND" WAS A COLLECTIVE INVOLVING MORE THAN 50 OTHER ARTISTS... AMONG WHOM PERHAPS THE MOST FAMOUS WAS DAMIEN HIRST.

WHO MADE THE SKULL COVERED WITH DIAMONDS?

EXACT-LY.

BANKSY CREATED SOME OF THE ART PIECES, LIKE THE CINDERELLA COACH, AND ORGANIZED EVERYTHING... A GIGANTIC PROJECT THAT STAYED OPEN FOR FIVE WEEKS AND WAS VISITED BY 150,000 PEOPLE.

A THEME PARK... THE THEME OF WHICH IS DESOLATION AND DISAPPOINTMENT...

MAGNIFICENT!

I'M SERIOUS, WOULDN'T YOU RATHER DO SOMETHING LIKE THAT THAN LIMIT YOURSELF TO TALKING ABOUT IT ON VIDEO?

OF COURSE I WOULD!

WHAT A QUESTION!

WHEN I FIRST SUGGESTED IT YOU ALMOST KICKED ME!

KICKING PEOPLE IS NOT MY STYLE.

JUST SAYING.

I ADMIT, IT WOULD BE GREAT TO DO SOMETHING...

... LIKE *BARELY LEGAL,* WHICH WE ALREADY TALKED ABOUT.

AROUND THE SAME TIME BANKSY REALIZED THE INSTALLATION *BREAKING* AT DISNEYLAND. HE MANAGED TO GET PAST THE FENCE ENCLOSING THE AREA WHERE THE ROLLER COASTERS PASS WITHOUT GETTING CAUGHT BY SECURITY...

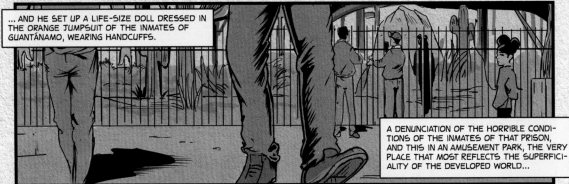

... AND HE SET UP A LIFE-SIZE DOLL DRESSED IN THE ORANGE JUMPSUIT OF THE INMATES OF GUANTÁNAMO, WEARING HANDCUFFS.

A DENUNCIATION OF THE HORRIBLE CONDITIONS OF THE INMATES OF THAT PRISON, AND THIS IN AN AMUSEMENT PARK, THE VERY PLACE THAT MOST REFLECTS THE SUPERFICIALITY OF THE DEVELOPED WORLD...

ORANGE JUMPSUITS?

EXACTLY...

... A LITTLE LIKE THE ONES WE WEAR WHEN WE REPAINT THE WALLS, RIGHT?

ANYWAY, YES... WE REALLY SHOULD CREATE SOMETHING OF OUR OWN.

?

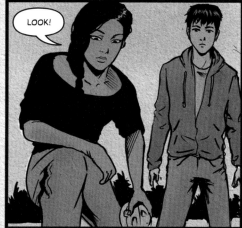

LOOK!

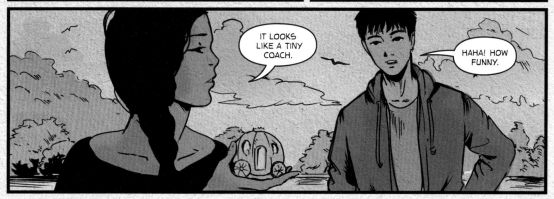

IT LOOKS LIKE A TINY COACH.

HAHA! HOW FUNNY.

IT DOESN'T LOOK LIKE A TOY... BUT IT WAS PROBABLY LOST BY SOME CHILD.

CHAPTER 4

3130

RRRING

YOU MADE IT!

COME ON UP!

YOU'RE LATE. DID YOU HAVE A HARD TIME FINDING IT??

NOT AT ALL.

I JUST SPENT SOME TIME LOOKING AROUND.

THERE ARE A LOT OF WHITE WALLS AROUND HERE.

DON'T EVEN THINK OF IT!

HEHE! JUST KIDDING!

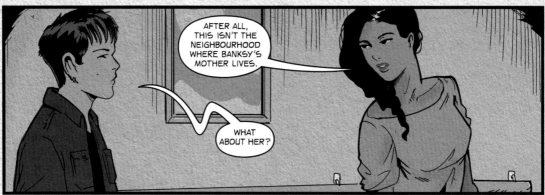

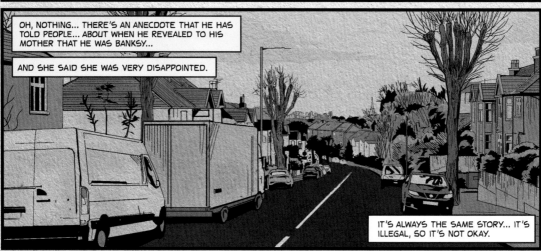

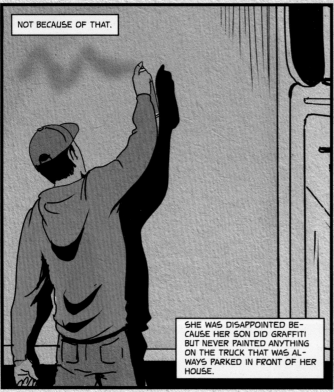

WOW! YOU'VE SET UP A GREAT STUDIO HERE!

IF WE WANT TO MAKE GOOD VIDEOS, WE HAVE TO BE PROFESSIONAL! BUT WHAT...

... ABOUT YOU, DID YOU DO YOUR PREPARATIONS?

OF COURSE! WHO DO YOU THINK I AM?

JUST ASKING.

IT'S ONE OF THE EPISODES OF BANKSY'S CAREER THAT HAS MADE ME LAUGH THE MOST.

ALONG WITH THAT STORY OF MELVYN BRAGG'S.

THE TV BROADCASTER?

YES... HE SAID THAT HE ONCE INVITED BANKSY TO THE AWARDS CEREMONY FOR THE SOUTH BANK SHOW AWARDS, AND THAT BANKSY ACCEPTED!

REALLY?

LET ME TELL THE STORY.

EVERYONE WAS ANXIOUSLY AWAITING HIM, BUT AS SOON AS HE ARRIVED THEY NOTICED SOMETHING WAS OFF.

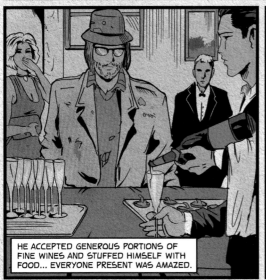

HE ACCEPTED GENEROUS PORTIONS OF FINE WINES AND STUFFED HIMSELF WITH FOOD... EVERYONE PRESENT WAS AMAZED.

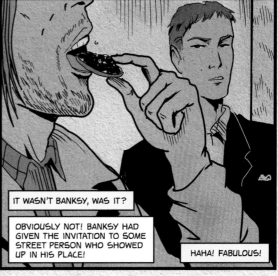

IT WASN'T BANKSY, WAS IT?

OBVIOUSLY NOT! BANKSY HAD GIVEN THE INVITATION TO SOME STREET PERSON WHO SHOWED UP IN HIS PLACE!

HAHA! FABULOUS!

THOSE ARE THE THINGS I LIKE ABOUT HIM, HIS HOSTILITY TOWARDS INSTITUTIONALIZED ART.

HOSTILITY?

I'VE BEEN THINKING ABOUT IT.

AND DON'T SAY YOU'RE SURPRISED, BECAUSE IT DIDN'T EVEN MAKE YOU LAUGH THE FIRST TIME!

IF YOU'RE GOOD, I'LL EXPLAIN IT TO YOU LATER.

3, 2, 1...

ACTION!

CLICK

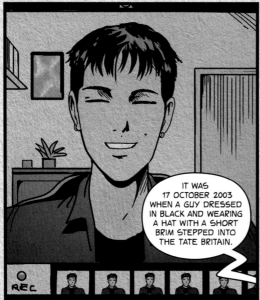

IT WAS 17 OCTOBER 2003 WHEN A GUY DRESSED IN BLACK AND WEARING A HAT WITH A SHORT BRIM STEPPED INTO THE TATE BRITAIN.

REC

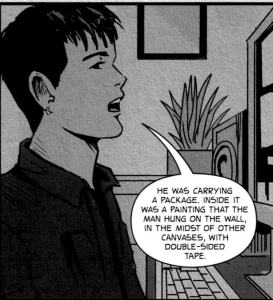

HE WAS CARRYING A PACKAGE. INSIDE IT WAS A PAINTING THAT THE MAN HUNG ON THE WALL, IN THE MIDST OF OTHER CANVASES, WITH DOUBLE-SIDED TAPE.

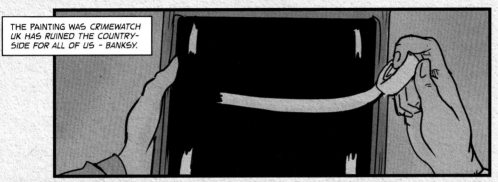

THE PAINTING WAS *CRIMEWATCH UK HAS RUINED THE COUNTRY-SIDE FOR ALL OF US* - BANKSY.

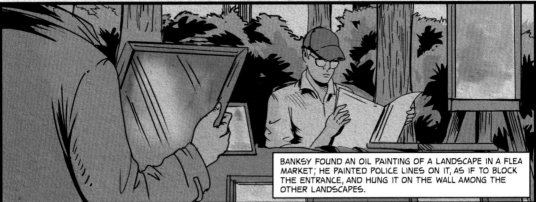

BANKSY FOUND AN OIL PAINTING OF A LANDSCAPE IN A FLEA MARKET; HE PAINTED POLICE LINES ON IT, AS IF TO BLOCK THE ENTRANCE, AND HUNG IT ON THE WALL AMONG THE OTHER LANDSCAPES.

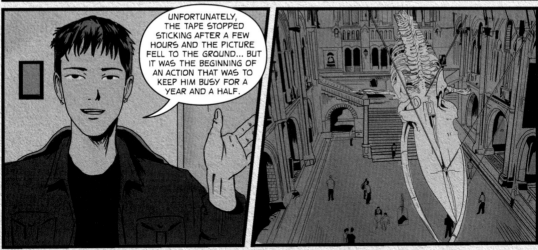

UNFORTUNATELY, THE TAPE STOPPED STICKING AFTER A FEW HOURS AND THE PICTURE FELL TO THE GROUND... BUT IT WAS THE BEGINNING OF AN ACTION THAT WAS TO KEEP HIM BUSY FOR A YEAR AND A HALF.

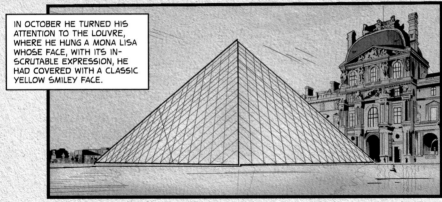

IN OCTOBER HE TURNED HIS ATTENTION TO THE LOUVRE, WHERE HE HUNG A MONA LISA WHOSE FACE, WITH ITS IN-SCRUTABLE EXPRESSION, HE HAD COVERED WITH A CLASSIC YELLOW SMILEY FACE.

AND THEN IN MAY OF 2003 HE WENT BACK TO LONDON AND SET UP SOME FAKE ROCK GRAFFITI IN THE BRITISH MUSEUM...

THE IMAGE ON THE ROCK AT FIRST LOOKS LIKE A STONE AGE HUNTING SCENE BUT IS REALLY A HUMAN FIGURE PUSHING A SHOPPING TROLLEY.

ONLY A LITTLE BEFORE THAT HE PULLED OFF HIS "BIG COUP", INFILTRATING FOUR DIFFERENT NEW YORK MUSEUMS AND HANGING PICTURES THERE...

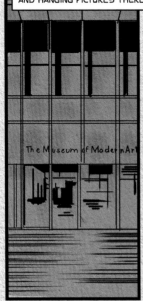
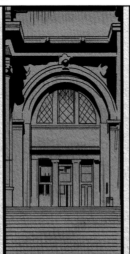
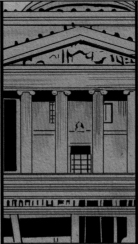
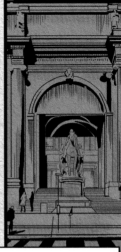

AS BANKSY HIMSELF SAID, GETTING ONE OF HIS PIECES CHOSEN TO APPEAR IN ANY OF THESE MUSEUMS IS A LONG AND TEDIOUS PROCESS.

IT'S MUCH MORE FUN TO GO STRAIGHT IN AND HANG THEM UP WITHOUT PERMISSION!

I'M ADAM, CLAIRE RUNS REGIE, SUBSCRIBE TO OUR CHANNEL "HIS NAME IS BANKSY"!

OKAY, CUT!

CLICK

WOW!

YOU ARE A SOURCE OF CONTINUAL SURPRISES!

I PRACTISED IN FRONT OF THE MIRROR!

JUST A FEW CUTS, THEN WE PUT THE PICTURES OF THE WORKS OVER IT AND THAT'S IT...

WHAT WERE YOU SAYING EARLIER, ABOUT BANKSY'S HATRED OF INSTITUTIONALIZED ART?

I WOULDN'T CALL IT HATRED... I DON'T KNOW, IT'S NOT AS IF I KNOW HIM PERSONALLY...

... HOWEVER...

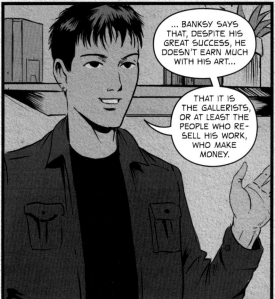

... BANKSY SAYS THAT, DESPITE HIS GREAT SUCCESS, HE DOESN'T EARN MUCH WITH HIS ART...

THAT IT IS THE GALLERISTS, OR AT LEAST THE PEOPLE WHO RESELL HIS WORK, WHO MAKE MONEY.

HE HAS ALSO DECLARED HIMSELF AGAINST COPYRIGHTS, WHICH IS WHY HE DOESN'T EVEN DO MUCH TO STOP PEOPLE WHO SELL UNAUTHORIZED REPRODUCTIONS OF HIS WORK... BUT...

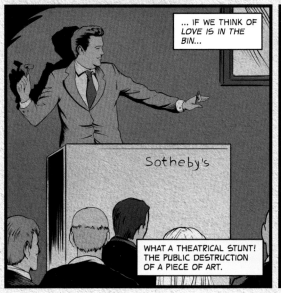

... IF WE THINK OF *LOVE IS IN THE BIN*...

WHAT A THEATRICAL STUNT! THE PUBLIC DESTRUCTION OF A PIECE OF ART.

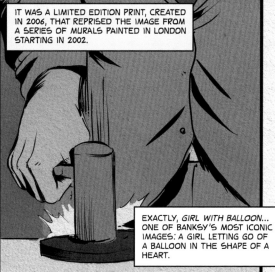

IT WAS A LIMITED EDITION PRINT, CREATED IN 2006, THAT REPRISED THE IMAGE FROM A SERIES OF MURALS PAINTED IN LONDON STARTING IN 2002.

EXACTLY, *GIRL WITH BALLOON*... ONE OF BANKSY'S MOST ICONIC IMAGES: A GIRL LETTING GO OF A BALLOON IN THE SHAPE OF A HEART.

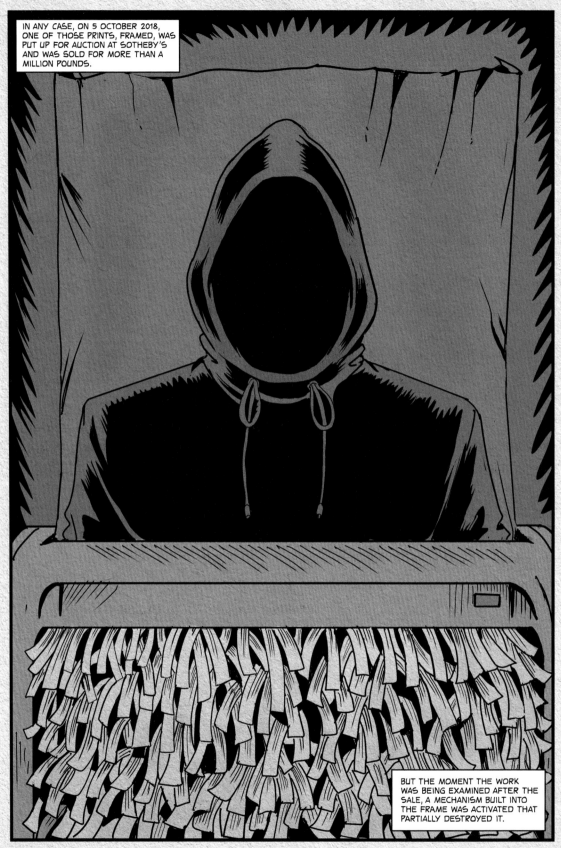

IN ANY CASE, ON 5 OCTOBER 2018, ONE OF THOSE PRINTS, FRAMED, WAS PUT UP FOR AUCTION AT SOTHEBY'S AND WAS SOLD FOR MORE THAN A MILLION POUNDS.

BUT THE MOMENT THE WORK WAS BEING EXAMINED AFTER THE SALE, A MECHANISM BUILT INTO THE FRAME WAS ACTIVATED THAT PARTIALLY DESTROYED IT.

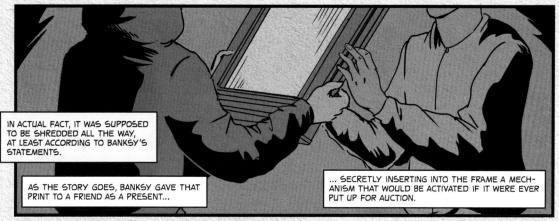

IN ACTUAL FACT, IT WAS SUPPOSED TO BE SHREDDED ALL THE WAY, AT LEAST ACCORDING TO BANKSY'S STATEMENTS.

AS THE STORY GOES, BANKSY GAVE THAT PRINT TO A FRIEND AS A PRESENT...

... SECRETLY INSERTING INTO THE FRAME A MECHANISM THAT WOULD BE ACTIVATED IF IT WERE EVER PUT UP FOR AUCTION.

ONE THING'S FOR SURE: IN ADDITION TO STAGING AN EXCELLENT PERFORMANCE, WITH THIS ACTION BANKSY ALSO SENT AN UNMISTAKABLE MESSAGE TO THE ART ESTABLISHMENT.

BASICALLY HE SAID: "I DON'T ACKNOWLEDGE YOUR POWER OR YOUR ROLE. HERE, I'M THE ONE WHO MAKES THE RULES!"

AND THAT INSPIRED ME.

I'M NOT SURE I UNDERSTAND.

TRUST ME, CLAIRE.

WE'RE IN AGREE-MENT THAT WE WANT TO CREATE A WORK OF OUR OWN, RIGHT?

I DON'T THINK I EVER SAID ANY SUCH THING!

BUT IF YOUR ONLY OBJEC-TIONS WERE ABOUT THE COST...?

HOW MUCH DID THOSE HELIUM TANKS COST?

LESS THAN YOUR HOME TV STUDIO, DON'T WORRY.

96

AND IT IS ALWAYS THE IDEA THAT AL-LOWS YOU TO STEP OUTSIDE OF THE LOGIC OF TRADITIONAL ART!

ABOUT THAT TOPIC.

ABOUT THIS TOPIC.

YOU'VE SEEN THE FILM *EXIT THROUGH THE GIFT SHOP?*

OF COURSE! IT WAS DIRECTED BY BANKSY.

HE PRESENTED IT AT THE SUN-DANCE FILM FES-TIVAL IN 2010.

EXACTLY.

IT'S ABOUT THIERRY GUETTA... AN OB-SESSED VIDEOGRAPHER WHO AT SOME POINT DECIDES TO MAKE A DOCUMEN-TARY ABOUT STREET ART...

THE RESULTS DID NOT CONVINCE BANKSY... BUT HE IS AN EXTREMELY FUNNY PERSONALITY, AND SO BANKSY DECIDES TO TURN THE TABLES AND MAKE A FILM ABOUT GUETTA.

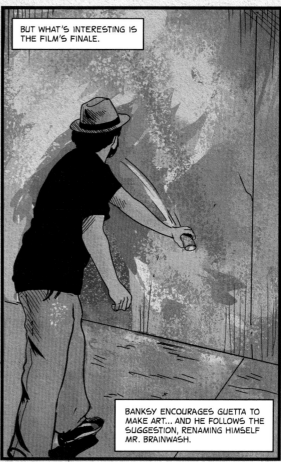

BUT WHAT'S INTERESTING IS THE FILM'S FINALE.

BANKSY ENCOURAGES GUETTA TO MAKE ART... AND HE FOLLOWS THE SUGGESTION, RENAMING HIMSELF MR. BRAINWASH.

AT ANY RATE, MR. BRAINWASH ORGANIZES THIS HUGE SHOW IN AN OLD HOLLYWOOD STUDIO.

BUT IN THAT CASE THE FINANCIAL RESOURCES WERE GIVEN!

YES, BUT THAT'S NOT THE POINT HERE!

THE EVENT ATTRACTED A LOT OF VISITORS, NOT LEAST BECAUSE OF THE ENDORSEMENT OF BANKSY HIMSELF AND OF SHEPARD FAIREY.

HIS WORK SELLS AT VERY HIGH PRICES, IT'S A HUGE SUCCESS.

IT'S A SLAP IN THE FACE TO THE "ART SYSTEM" AS A WHOLE.

MORE THAN ANYTHING ELSE, IT'S A DEMONSTRATION OF THE ABSURDITY OF THE MACHINERY THAT REGULATES CONTEMPORARY ART...

... WHICH IS DEFINED AS ART BY THOSE WHO HAVE BEEN INSTITUTIONALLY AUTHORIZED TO DO SO.

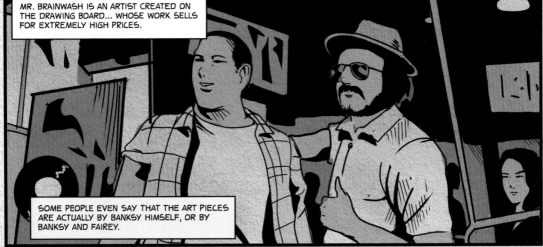

MR. BRAINWASH IS AN ARTIST CREATED ON THE DRAWING BOARD... WHOSE WORK SELLS FOR EXTREMELY HIGH PRICES.

SOME PEOPLE EVEN SAY THAT THE ART PIECES ARE ACTUALLY BY BANKSY HIMSELF, OR BY BANKSY AND FAIREY.

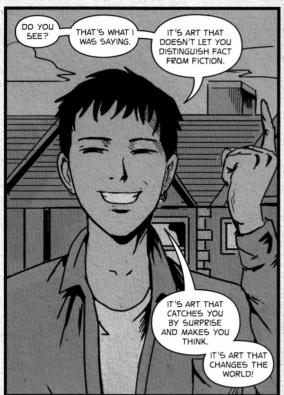

DO YOU SEE?

THAT'S WHAT I WAS SAYING.

IT'S ART THAT DOESN'T LET YOU DISTINGUISH FACT FROM FICTION.

IT'S ART THAT CATCHES YOU BY SURPRISE AND MAKES YOU THINK.

IT'S ART THAT CHANGES THE WORLD!

SHALL WE GO ON?

FSSST

ORDINARY BALLOONS?

I COULDN'T FIND ANY HEART-SHAPED ONES!

FSSSST

FSSST

AND
NOW?

NOW YOU HAVE TO TIE THEM LIKE THIS.

AT THE HEM OF THE WALL

WALLS DON'T HAVE HEMS!

NORMAL-LY THEY DON'T...

... BUT WE'RE TALKING ABOUT ART.

AND SO WALLS CAN BECOME ANY-THING WE WANT THEM TO.

MMM...

FOR ME...

... IT DOESN'T MAKE MUCH SENSE.

ONLY IF YOU THINK ABOUT IT TOO MUCH.

THERE ARE PROJECTS THAT MAKE YOU SEE BEYOND REALITY.

AND THAT'S WHAT WE'RE TRYING TO DO.

YOU'LL LIKE IT, PARTNER!

3...

2...

1...

I LIKE IT...

... PARTNER.

BEYOND THE WALL

COOL, HUH?

THEY LIKE IT.

THEY LOVE IT!

OKAY, OKAY! YOU WERE RIGHT!

THIS TIME YOU HAD A GREAT IDEA!

REALLY IT'S ALL BECAUSE OF YOU...

IF YOU HADN'T DRAGGED ME DOWN THE RABBIT HOLE OF BANKSY, I NEVER WOULD HAVE THOUGHT OF ANYTHING LIKE THIS.

WELL... AND IF YOU HADN'T THROWN THAT SPRAY CAN AT ME, NOTHING THAT WE HAVE DONE TOGETHER WOULD EVER HAVE EXISTED!

SHALL WE SAY IT'S MERIT OF US BOTH?

UMMM... OKAY.

BUT MAYBE A LITTLE MORE OF ME, NO?

THERE'S ONE THING WE HAVEN'T TALKED ABOUT THOUGH.

AND THAT IS?

WHO THE DEVIL IS BANKSY REALLY?

HA HA HA!

IMPOSSIBLE TO KNOW.

MANY HYPOTHESES HAVE BEEN PUT FORWARD, BUT WHO KNOWS?

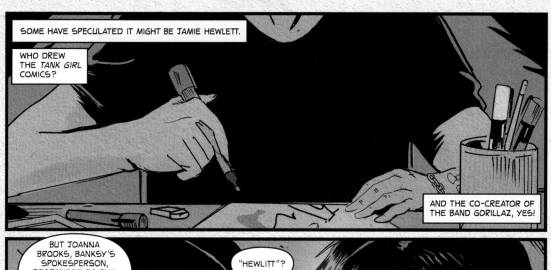

SOME HAVE SPECULATED IT MIGHT BE JAMIE HEWLETT.

WHO DREW THE *TANK GIRL* COMICS?

AND THE CO-CREATOR OF THE BAND GORILLAZ, YES!

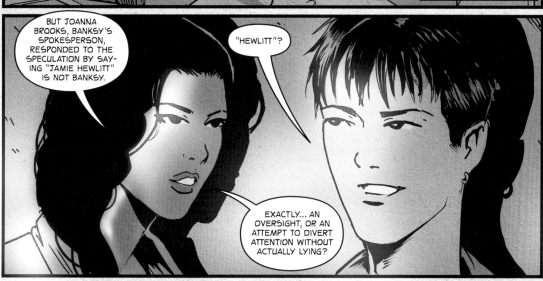

BUT JOANNA BROOKS, BANKSY'S SPOKESPERSON, RESPONDED TO THE SPECULATION BY SAYING "JAMIE HEWLITT" IS NOT BANKSY.

"HEWLITT"?

EXACTLY... AN OVERSIGHT, OR AN ATTEMPT TO DIVERT ATTENTION WITHOUT ACTUALLY LYING?

ANOTHER RUMOUR SAYS BANKSY IS ROBERT DEL NAJA, MEMBER OF THE BAND MASSIVE ATTACK...

... BUT ALSO A STREET ARTIST, KNOWN BY THE NAME OF 3D.

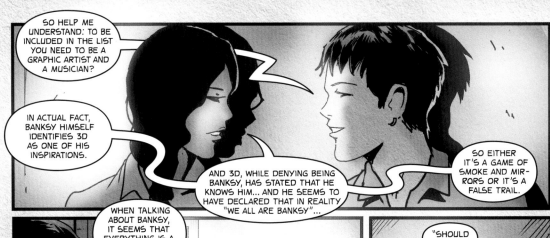

SO HELP ME UNDERSTAND: TO BE INCLUDED IN THE LIST YOU NEED TO BE A GRAPHIC ARTIST AND A MUSICIAN?

IN ACTUAL FACT, BANKSY HIMSELF IDENTIFIES 3D AS ONE OF HIS INSPIRATIONS.

AND 3D, WHILE DENYING BEING BANKSY, HAS STATED THAT HE KNOWS HIM... AND HE SEEMS TO HAVE DECLARED THAT IN REALITY "WE ALL ARE BANKSY"...

SO EITHER IT'S A GAME OF SMOKE AND MIRRORS OR IT'S A FALSE TRAIL.

WHEN TALKING ABOUT BANKSY, IT SEEMS THAT EVERYTHING IS A GAME OF SMOKE AND MIRRORS.

AND THAT IS PART OF HIS CHARM, AT LEAST FOR ME...

BUT BOTH HEWLETT AND DEL NAJA ARE ABOUT 10 YEARS OLDER THAN WHAT BANKSY SHOULD BE.

"SHOULD BE"?

OF COURSE... THEY SAY HE WAS BORN IN BRISTOL IN 1974, BUT HOW CAN WE BE SURE?

THE HYPOTHESES THAT HAVE EMERGED OVER THE YEARS ARE SO MANY... ONE OF THE MOST POPULAR REFERS TO ROBIN GUNNINGHAM!

WHO?

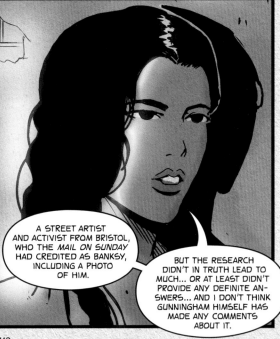

A STREET ARTIST AND ACTIVIST FROM BRISTOL, WHO THE *MAIL ON SUNDAY* HAD CREDITED AS BANKSY, INCLUDING A PHOTO OF HIM.

BUT THE RESEARCH DIDN'T IN TRUTH LEAD TO MUCH... OR AT LEAST DIDN'T PROVIDE ANY DEFINITE ANSWERS... AND I DON'T THINK GUNNINGHAM HIMSELF HAS MADE ANY COMMENTS ABOUT IT.

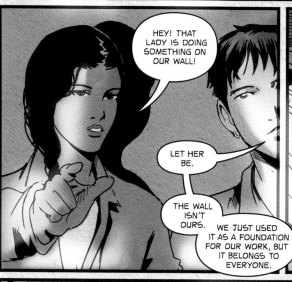

HEY! THAT LADY IS DOING SOMETHING ON OUR WALL!

LET HER BE.

THE WALL ISN'T OURS. WE JUST USED IT AS A FOUNDATION FOR OUR WORK, BUT IT BELONGS TO EVERYONE.

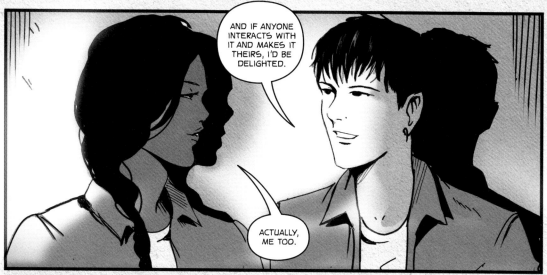

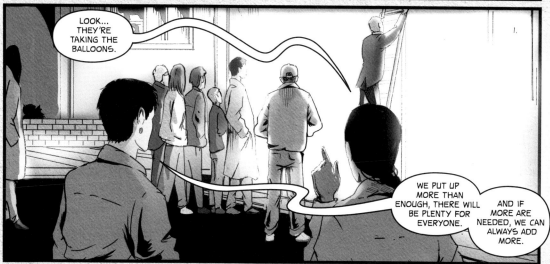

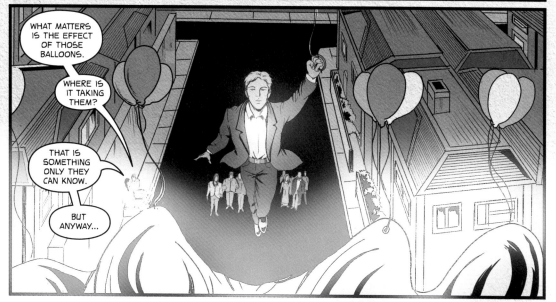

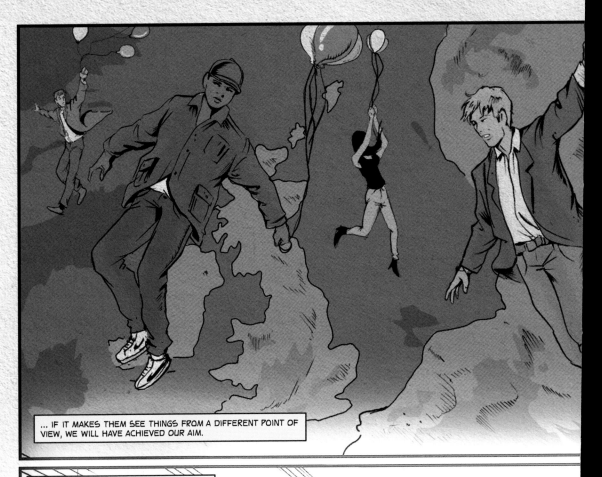

... IF IT MAKES THEM SEE THINGS FROM A DIFFERENT POINT OF VIEW, WE WILL HAVE ACHIEVED OUR AIM.

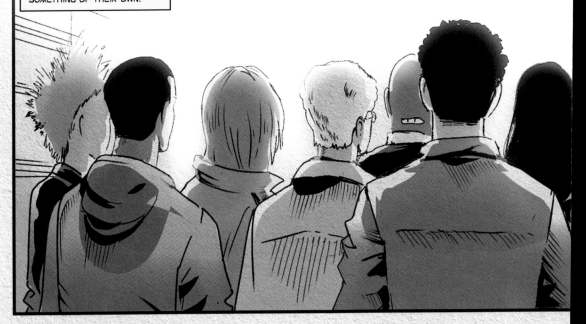

SOME PEOPLE WILL LIMIT THEMSELVES TO LOOK AT WHAT WE HAVE CREATED.

AND SOME WILL DECIDE TO ADD SOMETHING OF THEIR OWN.

THE IMPORTANT THING IS TO PROVOKE A REACTION!

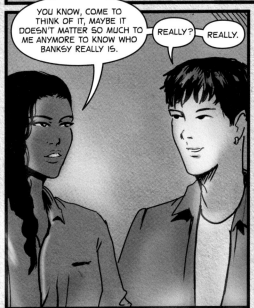

YOU KNOW, COME TO THINK OF IT, MAYBE IT DOESN'T MATTER SO MUCH TO ME ANYMORE TO KNOW WHO BANKSY REALLY IS.

REALLY?

REALLY.

MAYBE IT'S A MAN, MAYBE IT'S A WOMAN, OR A COLLECTIVE OF PEOPLE. WHAT DIFFERENCE...

... WOULD IT MAKE?

AN INTERESTING MYSTERY IS BETTER THAN A BORING ANSWER!

IT COULD BE ANYONE!

FOR ALL WE KNOW, IT COULD EVEN BE YOU...

HA! HA! YEAH, FOR SURE!

IF YOU PUT IT LIKE THAT, IT COULD BE YOU TOO!

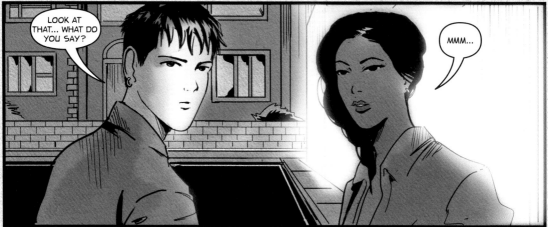

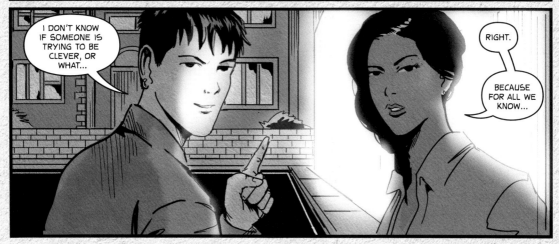

... IT COULD BE YOU!

AFTERWORD

His name *is not* Banksy

Let's clear up a misunderstanding: Banksy is not a person.

Of course, somewhere there is someone who, at certain moments, assumes the nom de plume "Banksy" and creates works of art or artistic actions. Someone who, undoubtedly, in his own life also does things that have nothing to do with the Banksy project.

And who, on an artistic level, does not limit himself to creating art pieces and murals, but rather, carefully and calculatedly, manages all of the communication about everything having to do with Banksy.

Because, let's admit it, most of the things we know about his life are things he himself has told us (and I use "he" as a pronoun of convenience; the story goes that Banksy is a person – a single individual – of male gender; but how can we really know that's the case?).

If everything we know about Banksy has been told to us by him, how do know it is reliable information, having to do with someone who has always worked to preserve his anonymity and keep his identity secret?

Accordingly, trying to find out who he is means stepping into the shoes of a detective forced to base an investigation solely on clues provided by the person he is supposed to track down. A lost cause.

But, in fact, this is not really a problem for Banksy.

When, on 13 July 2008, the *Mail on Sunday* published the investigation, complete with photographic evidence, which claimed to reveal the identity of the mysterious graffiti artist from Bristol, one could have imagined there would be some kind of impact. The revelation seemed important enough to represent the end of an era. But practically nothing happened: Banksy's spokesperson merely declared that the conclusions reached by the newspaper were incorrect, and that was the end of it. Because in actual fact, no one really wants to know who Banksy is. It is understandable that some journalist or other, looking for a scoop, might decide to try to identify the person behind the pseudonym, but most of the people who love Banksy and his work prefer for things to remain as they are.

This, I think, is precisely the point: mysteries are only beautiful and fascinating until they are solved, after which they become nothing but a banal fact. And the figure of Banksy lives immersed in this concept: his elusiveness, the irony of being there without really being there (or perhaps the reverse), is one of the elements that make him great.

The murals that appear by night in the streets of London or on the Gaza wall, the shows kept secret until the last minute, the screen prints, the street art installations: to take the reasoning to the extreme, are we even sure that "works" is the most appropriate term to define all of this? My point of view will probably make some art lovers or critics shake their heads, but I am convinced that defining them as such is too simple.

They are fragments of a myth: physical evidence of the existence of an exceptional and elusive artistic entity. And they are all that we, as mere mortals, can ever get a hold of. Not simple artworks, but pieces of the great legend made up of both Banksy's entire body of artistic work and by his very figure.

Because Banksy, it is worth repeating, is not a person.

He is much more than that. Banksy is the true, unique work of art, brilliant and astonishing. A work of art that is ineffable, enormous and pervasive, which, for all we know, could manifest at any time and in any place.

A work so great that no one will ever be able to acquire it.

Francesco Matteuzzi

Thanks to Balthazar, for inviting me aboard for this new adventure, and to Marco, the perfect co-author. And thanks to Laura, who put up with my Banksy-mania way beyond the limit.
F. M.

A big thank you to my family, Enrico, Igor, Matteo, Giulia and Yu Cai for their support in the making of this book.
M. M.

Bibliography

Stefano Antonelli and Gianluca Marziani, *Banksy*, Florence 2021

Banksy, *Wall and Piece*, London 2006

Duccio Dogheria, *Banksy*, Florence 2020

Alessandra Mattanza, *Banksy*, Munich et al. 2021

Gianni Mercurio (ed.), *A Visual Protest: The Art of Banksy* (exhibit. cat., Milan, MUDEC), Munich et al. 2020

Gianni Mercurio (ed.), *La vera arte è non farsi beccare. Interviste a Banksy*, Milan 2018

Gary Shove and Patrick Potter, *Banksy: You Are an Acceptable Level of Threat and If You Were Not You Would Know About It*, Darlington, UK 2013

Steve Wright, *Banksy's Bristol: Home Sweet Home*, Bristol 2014

Filmography

Banksy (dir.), *Exit Through the Gift Shop*, 2010

Elio España (dir.), *Banksy and the Rise of Outlaw Art*, 2020

Marco Proserpio (dir.), *L'uomo che rubò Banksy*, 2018

© Prestel Verlag, Munich · London · New York, 2022
A member of Penguin Random House Verlagsgruppe GmbH
Neumarkter Straße 28 · 81673 Munich

Original title: *Il suo nome è Banksy*
Copyright © BesideBooks s.r.l. 2022
This book was devised and edited by Balthazar Pagani.
Copyright texts © Francesco Matteuzzi 2022
Copyright illustrations © Marco Maraggi 2022

Editorial direction Prestel: Claudia Stäuble
Project management Prestel: Andrea Bartelt-Gering
Translation from Italian: Katharine Cofer
Typesetting: VerlagsService Dietmar Schmitz GmbH
Copyediting: Jonathan Fox
Design and layout: Studio RAM
Production management: Luisa Klose
Separations: Schnieber Graphik, Munich
Printing and binding: Alföldi, Hungary
Paper: Profimatt 150 g/m^2

Verlagsgruppe Random House FSC® N001967

Printed in Hungary

ISBN 978-3-7913-8881-6

www.prestel.com